AFTER CÉZANNE

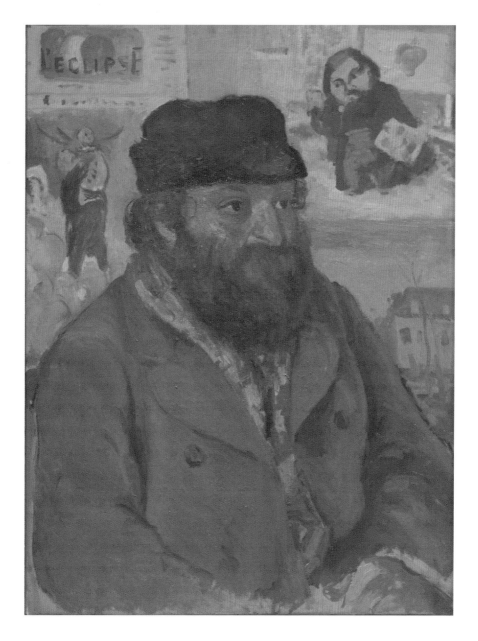

Camille Pissarro (1830-1903): *Portrait of Cézanne* (1875)

Oil on canvas, 73 x 59.7 cm. On loan to the National Gallery, London. © the collection of Laurence Graff OBE

Maitreyabandhu trained as a nurse at the Walsgrave Hospital, Coventry before going on to study fine art at Goldsmiths College, London. He started attending classes at the London Buddhist Centre (LBC) in 1986, and moved into a residential spiritual community above the LBC in 1987. He was ordained into the Triratna Buddhist Order in 1990 and given the name Maitreyabandhu. He lives and works at the LBC.

Maitreyabandhu has written three books on Buddhism, *Thicker than Blood: Friendship on the Buddhist Path* (2001), *Life with Full Attention: a Practical Course in Mindfulness* (2009) and *The Journey and the Guide: a Practical Course in Enlightenment* (2015) – all with Windhorse Publications. In 2010 he founded *PoetryEast*, an arts venue hosting writers and artists such as Antony Gormley, Jorie Graham, Colm Tóibín, Mark Doty and Wendy Cope.

Maitreyabandhu's poetry has won many awards including the Keats-Shelley Prize, the Basil Bunting Award, the Geoffrey Dearmer Prize and the Ledbury Poetry Festival Competition. His first pamphlet, *The Bond*, was a winner of the Poetry Business Poetry Book & Pamphlet Competition and shortlisted for the Michael Marks Award. His second pamphlet, *Vita Brevis,* won the Iota Shots Award and was a Poetry Book Society Pamphlet Choice. He has published three book-length collections with Bloodaxe: *The Crumb Road* (2013), which was a Poetry Book Society Recommendation, *Yarn* (2015), and *After Cézanne* (2019).

Christopher Lloyd was Surveyor of The Queen's Pictures from 1988 to 2005. He worked for many years in the Department of Western Art at the Ashmolean Museum, Oxford, and was appointed to a fellowship at Harvard University's Centre for Renaissance Studies, Villa I Tatti, in Florence. He has also been visiting research curator at the Art Institute of Chicago. His publications include *Paul Cézanne's Drawings and Watercolours* (Thames and Hudson, 2015) and *Picasso and the Art of Drawing* (Yale University Press, 2018).

MAITREYABANDHU

AFTER CÉZANNE

BLOODAXE BOOKS

Poems copyright © Maitreyabandhu 2019

ISBN: 978 1 78037 482 6

First published 2019 by
Bloodaxe Books Ltd,
Eastburn,
South Park,
Hexham,
Northumberland NE46 1BS.

www.bloodaxebooks.com
For further information about Bloodaxe titles
please visit our website and join our mailing list
or write to the above address for a catalogue.

Cover design: Neil Astley & Pamela Robertson-Pearce.

Printed in Great Britain by Bell & Bain Limited, Glasgow, Scotland, on
acid-free paper sourced from mills with FSC chain of custody certification.

'Talking about art is virtually useless'

– Cézanne to Émile Bernard, 26th May 1904

i.m. Alex Danchev (1955–2016)

ACKNOWLEDGEMENTS

Some of these poems, or earlier versions of them, were published in *Acumen, Brixton Review of Books, The Compass, Envoi, The High Window, Hotel, The Keats-Shelley Review, Long Poem Magazine, Magma, The New Humanist, The New Statesman, Oxford Poetry, PN Review, Poem, Poetry Ireland Review, The Poetry Review, Poetry Wales, Prole, The Rialto, Siècle 21* (France), *The Spectator,* and *Tears in the Fence.* 'One Hundred Cloche Hats' was runner up in the Keats-Shelley Prize, 2017. *A Cézanne Haibun,* originally intended for this collection, was published as a pamphlet by Smith | Doorstop (2019). Poems from *After Cézanne* appeared in a digital installation at StAnza, Scotland's Poetry Festival, 2017.

My thanks go to Barnaby Wright (Deputy Head of the Courtauld Gallery) for his encouragement, and to Christopher Lloyd for his wonderfully concise and lucid Foreword. Alex Danchev, author of *Cézanne: A Life* (Profile Books, 2013) and *The Letters of Paul Cézanne* (Thames and Hudson, 2013), originally agreed to write the Foreword, but Alex died suddenly not long after I interviewed him for *PoetryEast.* I have dedicated this collection to him.

I am grateful to Neil Astley for his unfailing generosity; to Sasha Dugdale for reading *After Cézanne* in manuscript; to Vishvantara Julia Lewis for her friendship and support; and to Warren Davis for proof-reading. I am especially grateful to Mimi Khalvati without whose guidance this collection could never have been written. And I am greatly indebted to Arts Council England for their generous support.

CONTENTS

FOREWORD

Paul Cézanne's reputation as an artist who stands at the threshold of modern art is incontrovertible, but it was hard won. Concerned at all times to learn from the lessons of the past and willing momentarily during the 1870s to align himself with the avant-garde art of the Impressionists, it was the two last decades of his life that were to be the most influential. Having by then established his independence and begun to attract attention it was only in relative isolation that he started to comprehend the full complexity of his most important challenge. This was to create a wholly convincing record on canvas or paper of those sensations that he personally experienced when confronting nature. For this he developed a technique of carefully juxtaposed brushstrokes in oil or watercolour combining drawing with colour to suggest spatial recession and to evoke a sense of atmosphere.

Cézanne stood out from the beginning. His startling appearance, direct manner, secretive ways and outspoken views indicated a sense of purpose from which he could not be deflected. Temperamentally he was a man of the south associated most closely with Provence having been born in Aix-en-Provence in 1839 where he died 69 years later. He was nurtured by the regional movement known as the Provencal Renaissance, which flourished from the middle of the nineteenth century and promoted local literature, science and art. Well-educated, Cézanne had a profound knowledge of classical literature and of French authors. For many years he was on good terms with the novelist Émile Zola and if he had not chosen to be a painter he could have been a poet. The artist's father, Louis-Auguste, was originally a successful hatmaker who became a banker. He regarded his son's choice of career as an act of disloyalty.

The family property on the outskirts of Aix-en-Provence was a *bastide* known as the Jas de Bouffan ('House of Winds'), which inspired some of Cézanne's finest work until its sale in 1899. An even more dominant aspect of the Provencal landscape was the historic Mont Sainte-Victoire, which during the artist's final years became not only one of his principal motifs but also a metaphor for his artistic aspirations.

Tempering Cézanne's identification with the south was his acknowledgement that Paris was the centre of the art world. It was where you went to train to become an artist, where you saw great works of art, where you sought success and where you could associate with kindred spirits. It was also where Cézanne met his future wife, Hortense Fiquet, with whom he had a son, Paul, who was born in 1872. The liaison was kept secret from Louis-Auguste.

Cézanne was realistic enough to recognise the practical advantages of Paris, but his relationship with the city was equivocal and following his father's death in 1886 he began to spend most of his time in Provence. While in Paris he moved in the circle of the Impressionists exhibiting with them on two occasions (1874 and 1877), and he was particularly close to Camille Pissarro before he subsequently formed more distant friendships with Auguste Renoir and Claude Monet. But, Cézanne was too independent to be part of a group and his uncompromising views meant that he stood aloof.

Consequently it was only towards the very end of his life, during the 1890s, that his significance as an artist began to be recognised owing mainly to exhibitions organised by sympathetic dealers such as Ambroise Vollard. The growing interest in Cézanne's late work then suddenly became widespread. Younger artists in his immediate circle were swiftly followed by those such as Picasso and Matisse who would themselves very soon determine the future course of art. His work particularly

appealed to poets, notably Rainer Maria Rilke, who especially admired Cézanne's watercolours on viewing them in Paris.

The author of the outstanding sequence of fifty-six poems published in the present volume trained as a painter and is therefore in an ideal position to reflect on all aspects of Cézanne's life and reputation. In addition, the poems show a keen awareness of the broader cultural context in which Cézanne worked at the turn of the nineteenth and twentieth centuries.

Cézanne was never a true narrative painter. He devised a number of highly imaginative erotic and violent scenes before 1880, which are either allegorical or inspired by literary sources and works by other artists such as Édouard Manet. But, such themes were discontinued. Or, rather, Cézanne learnt to channel his passions into specific themes such as the *Bathers*, which allowed him to continue examining the nude, or the *Card Players* which overlapped with his portraiture.

The great revelation of Cézanne's art during his final years lies in his treatment of landscape. The motifs that he had known in Provence when growing up now gained extra significance – the Jas de Bouffan, the unfinished Château Noir, the abandoned quarry at Bibémus and above all Mont Sainte-Victoire. He visited these sites repeatedly, often working alone almost up to the last day of his life.

Similarly, with the still lifes that were undertaken either at the Jas de Bouffan or in the studio at Les Lauves on the north side of Aix-en-Provence. The variety in these compositions extends from arrangements of deceptive simplicity to sudden outbursts of baroque splendour. A mournful note occurs with the selection of human skulls in place of more mundane objects.

Cézanne is an important artist because he sought solutions to difficult problems that defeated others. As he told the young writer Joachim

Gasquet, 'Nature is always the same and yet its appearance is always changing. It is our business as artists to convey the thrill of nature's permanence along with the elements and the appearance of all its changes'. Cézanne struggled with this dilemma almost single-handedly and often felt that he was failing. Yet, it is the very fact that he tried and the relentless way in which he drove himself onwards that has won the unceasing admiration of artists and art historians. Added to this is the human story behind the struggle – the impact on family life and personal relationships or the toll taken by the self-imposed and unrelenting physical and mental strain. All these aspects of Cézanne's ordeal are fused in Maitreyabandhu's remarkable poems, in which the varied forms of composition and wide range of reference provide a refreshingly unique insight into Cézanne's art. What is achieved here is an incomparable poetic expression of the artist's idiosyncrasies and manifold achievements.

CHRISTOPHER LLOYD

AFTER CÉZANNE

Cézanne and the Colour Palette

'Where's your oxide yellow and yellow ochre,
your cobalt blue and synthetic madder lake?'
he said, looking at Émile Bernard's palette
 when he was just about to paint.

'Where's your orpiment, your Persian red,
your lacquer red and carmine lake and green?
Where's your Prussian blue, for heaven's sake!
 your malachite and ultramarine?'

'Where, oh where, is your alizarin crimson,
your Veronese purple and peach black?
Mon Dieu! You need a rainbow's compensation
 for the genius you lack.'

The Method of Loci

In the first room, the curator has placed the apple
on Madame Brémond's light-ruffled tablecloth,
vast, like sculpture by Claes Oldenburg.

In the second, the mountain is reduced
to papier-mâché and chicken wire
with sponge for trees and an OO-gauge railway

that takes you to the third where card players
abandon their pipe smoke and bucolic calm
to bark Provençal aphorisms and smut.

The girl leaving the fourth room with rustling skirts
and a suggestion of *Fantasia de Fleurs*
is followed by biographers who want to know

about the 'late style' and *alla prima*
in the fifth room, in which air holes and breathing
spaces open, blues fold stiffly away, reds

judder slightly like kissing gates as you squeeze
between them back into the first room
for the endless confrontation with the apple.

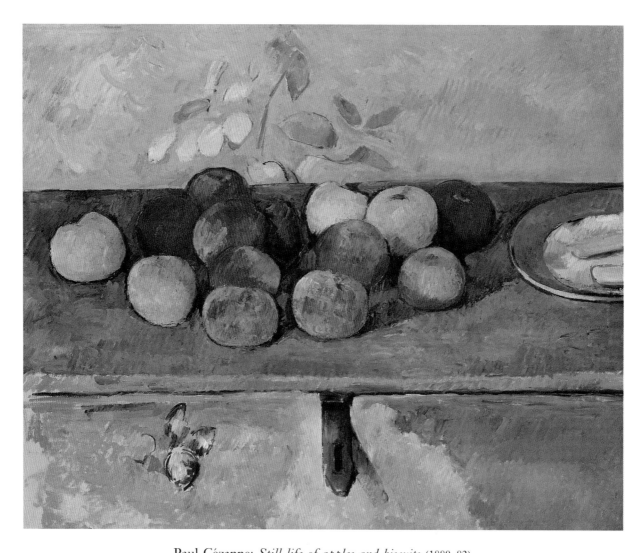

Paul Cézanne: *Still life of apples and biscuits* (1880–82)

Oil on canvas. Musée de l'Orangerie, Paris, France / Bridgeman Images.

One Hundred Cloche Hats

Before Braque gave Picasso a box of bell-shaped
Cézanne hats, 'the envy of Second Empire bookkeepers';
before Picasso made his riddle-image in violin colours –
a battered panache with fingers and a cravat; before
Braque rediscovered sky at Varengeville-sur-Mer –
the bird with its nest, the weeding machine knackered
beside a field of wheat or flax – a fight broke out
in the playground of Collège Bourbon: boys piled in
and with spitting and scuffs the chant went up
to pick on the sensitive one, the boy with the lisp
and Frenchified accent: the scholarship boy, the parasite...
Cézanne got a thrashing trying to break it up
but next morning Zola, with bruised ribs and aching arms
or with Chinese burns and boxed ears or with
a torn shirt and a fat lip, gave him a basket of apples,
sealing their friendship then and there before they
appeared, the apples, unbruised and blushing, amicable
(touching or almost touching), in so many still lifes.

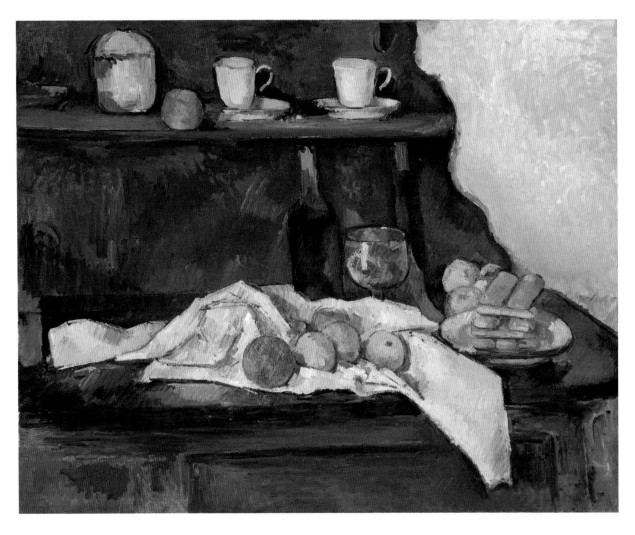

Paul Cézanne: *Le Buffet* (1877)

Oil on canvas, 65.5 x 81 cm. © Szépművészeti Múzeum / Museum of Fine Arts, Budapest, 2019

The Apple's Progress

The rosy apple passed down by the snake
with a putto's chubby face and toddler hands
to be taken by an already reaching Eve
restrained, at least dissuaded, by beefy Adam
in Ruben's copy of Titian's original
inspired by Raphael's fresco and Dürer's print,
appears a hundred and fifty years later
in *Le Buffet*, another still life by Cézanne.

This orange, if it is an orange, finding
its necessary weight. This lemon turned
towards the orange, which is so empathically
full-face. This propped-up apple almost erotic
in curvaceousness and stem-end. This distance –
intimate, standoffish – between the apple
and a second lemon. This fellowship of fruit,
these colours conversing together and apart.

The tablescape maintains a swaying balance
between illuminated and shaded – colour
begetting colour – its gaucheries at home
in evident design. Neither artful nor showy,
a few estimated and cherished things
join hands across a space with sensual fruit
and sugary biscuits; each teacup an actor-object
beset by touches, beguiled by troubled shape.

It might be summer's marriage hymn: a bottle
taciturn in brown, a chalice-beaker,
blue and bling, a cloth and walnut dresser –
each stubborn thing relieved of contradiction
by assiduity of thought. Love is a candle
lighting many candles without surcease.
It is this apple next to this lemon next to
this other lemon in a still life by Cézanne.

The Ambiguities of Place

Storm-weather might be preferable to this mildness
above a small, admittedly pretty, market town
where the mountains have shrunk to grassy slopes
and the element *water*, instead of being rough
in repeated assaults on harbour piers and bulwarks,
is a modest brook dithering behind the High Street.
The church is unlocked and a holly tree grows out
of the pavement. The Guildhall is nothing
to write home about and the chemist – packed
inside a black and white half-timbered cottage that,
heaven knows, Mary Arden might have visited –
sells the corn plasters, combs and pharmaceuticals
of any high street Boots. The market cross lost its cross
many years ago; it is protected from night revellers
(there are none) by spiked railings and Britain in Bloom.
There'd been a Motte-and-Bailey castle once
but the King's men, returning from the Battle of Evesham,
burnt it to the ground. Death of course had left
its common mark, small in the telescopic view –
my father dying in the dining room; a teenager killed
in front of Fine Fare; Geoffrey Gibbons the choirmaster…
There'd even been a murder: an identikit face
outside the police station and a ban on playing on the Mount.
You might have been born in such an ordinary town,
such a never-to-be-repeated now, where, against
your father's wishes and 'the vile people of Aix',

you painted absurdities, abduction and rape, with inept
draughtsmanship and disgusted paint. It took forty years
to hammer your rage into an image of grace
and make something out of the ambiguities of place.

Angels in Peckham

And Blake saw angels clustering like raindrops
in a tree on Peckham Rye; he saw their wings
and felt their love, the rush of their erotic mouths.
His feet stood on the verge of non-existence
'For man has closed himself up, till he sees all things
thro' the narrow chinks of his cavern.' He saw himself
as a nothing left in darkness. Then God pressed
his forehead to the sky, breathed against the glass,
then rubbed it with his cuff where Cézanne –
belligerent and ignored – worked 'agonisingly slowly',
weighing up each branch the mistral swept against,
pushing towards a sight beyond his sight, elbowing away
shadow, tone, modelling, outline, and answering
Nobodaddy with blue, blue-grey, violet, red.

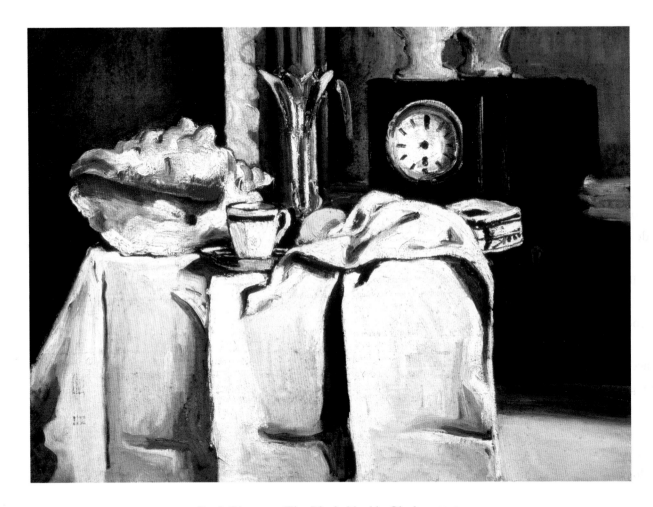

Paul Cézanne: *The Black Marble Clock* (*c.* 1870)

Oil on canvas. Private collection / Bridgeman Images.

The Black Clock

The first tablecloth, as far as I remember, or the first
to play an active part, was in *The Black Clock*,
the painting Zola hung in his cluttered dining room.

Cézanne was cadging money and trying to hide the truth
about Hortense and little Paul from Louis-Auguste –
'It's beginning to take on the air of a vaudeville farce.'

The painting is halfway between his ballsy style,
his *manière couillarde*, and his great maturity, so the blacks –
the decorative band of the coffee cup, the clock itself –

are still foreboding. Picasso stole the lemon, dead centre,
although the yellow is surely Braque's: a dun yellow,
saddened by northern grey. The conch shell

balanced on the edge is a studio prop never to be re-used
although its lip and coil are mimicked by a ruck
in the tablecloth the lemon hides behind.

When you step back you realise just how much space
the cloth takes up – you've been envying the vase,
the little drama of the cup and saucer, Chardin-like

teetering on the brink – taking you forward
to so many tablecloths with a water jug, wine bottle
or plate of sugary biscuits resting on them

but also, now you look again, taking you back
to your own life and your mother laying out a cloth
for funerals and christenings with crisps and pickled onions,

sandwiches and Coke. So doesn't it make you wonder
if those tablecloths, ruffled over a table
or interrupting a wall – white greyed by shadow

or pinked by ripening fruit – if those tablecloths
do the work of benediction: fair linen to be rolled
not folded, chalice veil and coverlet, the winding sheet

of Jesus where he lay? And don't you think,
as you turn to join the daily crush, that the world
is not to be learned and thrown aside like casual litter

but reverted to and relearned in a lemon, a fluted vase –
weighing our inwardness against this out-ness
in a seashell's carnal mouth, a clock without its hands?

The Mannequins of Paris

The seasons come first to the mannequins
– mid-autumn colours, leather and suede –
but in the passages of Gardanne, around the belfry

of Chapelle des Pénitents, across lanes twisting
between banked-up houses to the coast,
to the sea itself turning pebbles and moon-grit,

the heat lingers, making it impossible to sleep
even with the windows open and the ocean
sounding, *boom*, *shush*, *boom*, through the house.

Something is ending – the boy doesn't run to him
anymore to be hoisted and tickled, doesn't cling
to his leg or walk along a wall holding his hand:

he is growing apart, growing gradually apart,
looking at his father and trying to frown.
Tomorrow Hortense will take him back with her

to Paris but for now he is sleeping on a narrow divan
not far from the waves that want to wake him
with a salvo of shingle-knocks and backwash.

His breath – while his father, quietly, very quietly,
pulls up a stool and takes out his sketchbook
(the moonlight is bright enough to draw by) –

is the smallest wave in the suffocating house,
lifting and dragging his body as he lies
on his side with little fisty hands and a closed eye.

Madame Cézanne with Anti-representational Effects

I have learnt to endure it, having my head
turned into a block with the same
formality, the same parted hair, choosing

my clothes like a man, being told how to hold
a glove or lift my chin until I have –
oh! – grown sick with sitting with my ankles

swollen and the chairback cutting into my back
without so much as a clock to listen to.
I have left my body to him, motionless

and heron-like – even my fingers don't move
or my lips. My eyes rest in their damp holes.
My mind has become the mind of somebody else,

someone with a quiet face and a grey bodice,
someone with altogether kinder relatives
who can walk into a house and call herself

its owner. We inhabit different rooms
in the same room. He closes the window
in a transparent house where I disappear between

the dresser and the tallboy. He stops and says
it is time to stop. And I can tell by his shoulder
and the fall of his arm if I will read to him tonight.

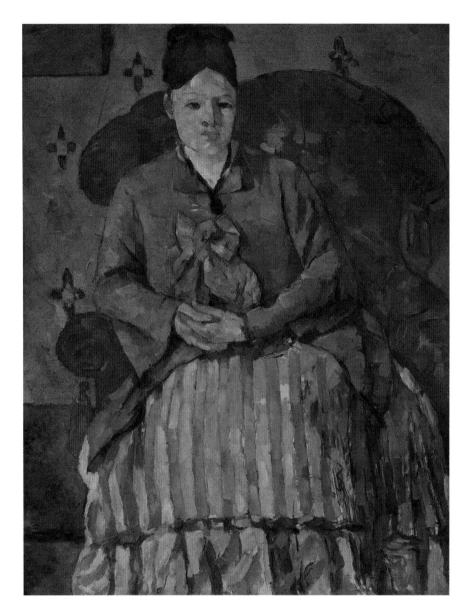

Paul Cézanne: *Madame Cézanne in a Red Armchair* (*c.* 1877)

Oil on canvas. Museum of Fine Arts, Boston, Massachusetts, USA /
Bequest of Robert Treat Paine, 2nd / Bridgeman Images.

Five Studies for Marie-Hortense

i.m. Leonard McComb (1930–2018)
You never got the retrospective you deserved, painter of peaches and apple-blossom birds.

I

On the last day of the Salon, Rilke wrote to his wife
about the bow on Madame Cézanne's blouse,
the colours of her face, how vulnerable
she seemed and lost, then in another painting –
clutching a handkerchief or possibly a flower –
so slight she seemed almost to levitate.
He rhapsodised the colour of her dress,
the wallpaper and how, walking home in rain
along Rue Cassette, he was already forgetting
which blue was next to which and what
the sleeves had said, what the armchair meant.

II

When the young Cézanne was lifedrawing
at the Suisse (drawings he'd rehash all his life),
he put a top hat and a scarf, a white scarf,
next to the model so he could better judge the tones
as when my tutor, Len McComb, showed me
a facsimile copy he'd made of Cézanne's portrait
of his wife – unassertive, almost dull in its
faithfulness to fact – then asked me to study
the highlights on Madame Cézanne's face,
her brow and inward-looking gaze, holding
a heavy sheet of cartridge paper up against her
to show me just how quiet a quiet white could be.

III

Infrared reflectogram shows her abandoned
under a picture of L'Estaque, her upper arm
and shoulder, when the canvas was turned around,
contributing to the hills around Marseille.
We know he had difficulty with her hands
and either left them out or left them bare.
As the picture developed, stroke by stroke,
he veiled her sympathetic face, deadening the eyes
by darkening the whites, working freely at first,
then making corrections. Sometimes he'd conclude
with anti-representational effects, closing off
the space so the affair and eventual marriage
had to be settled among the colours themselves.

IV

Is it sadness, quite – lost in a brown look
in a blue blouse with parted hair, against a wall
that gathers around her like her troubles?
Bored probably: sitting in a conservatory
or by a study of trees. And was it a present,
an apology or a plea, this little sketchbook
drawing, her head propped on her arm,
in bed, dreamy next to a study of hortensia?

V

Rewald found her money-grubbing, trivial and plain.
The painter's friends called her Dumpling
and gossiped in their mail. After Cézanne died,
she sold everything she could, not caring
if they were portraits of herself or of her son.
And yet she stayed with him all that time, sat
for portrait after portrait, forbidden to move,
seated in a red armchair or tilting her head.
Matisse is surely right about the wives of artists
who have to watch their foolish husbands
make a table with its legs up in the air.

Self-portrait of the Artist Wearing a Hat

Once I tried, like you, to sweat it out
mark by happy mark – I had a mountain
all my own and more grief and stupid rage
than I could shake a stick at. I stretched paper,
took my brush in hand and said to myself,
No romancing now, no cut and dash,
just this line here, no this, this emptied blue,
this grey. But the mountain was beyond me
and the pine trees creaked and lumbered off,
folding up the road behind them as they went.

I thought I'd draw myself in different guises –
half-profile in charcoal, wearing a hat
in pastel. The journey from the caruncle
to the upper lip was the longest journey.
A friend at art school copied your self-portrait
(full-face and twisting) but then one night a thief
broke in and stole it along with other things
he'd done – some trees, the herring fleet at Yarmouth –
leaving us with our prized unstolen pictures
and the choice to commiserate or resent.

Your portraits of Hortense are scattered now
to Saint Petersburg, Basel and New York –
argued about, X-rayed and reproduced,
they have become a fixture of the eye.
I only painted my lover once in denim
under London trees, darkening the whites
as you instructed, renouncing modelling
for *sensations colorantes* – his dirty blond,
his blue. But love has gone philandering
since then and time has taken up the brush.

Rilke on the Place de la Concorde

Rereading Rilke's letters on Cézanne,
it's the rain that stays, October rain,
day in, day out, lavering pavements,

choking sewers; Rilke wearing galoshes,
stepping around puddles, across
gutters, walking upstairs to the Salon

where all he could see were the Cézannes –
card players and chestnut trees flaring
between these gentlemen in frock-coats,

these ladies in the latest Paris fashions –
keeping a part of the world safe, no,
not safe, seen, like a glass of rain water.

Sunday Bells

A wine carafe,
a dish of plums –
each a glimpse of God

and radiant
in their separate heavens.
Rilke

might have said
the God-maker
is sunlight

– for what's
seen fully is eternal –
but Rilke

was working towards
the 'sublime dictation'
of the Sonnets

just as Cézanne
was worshipping
pine shadows and grapes.

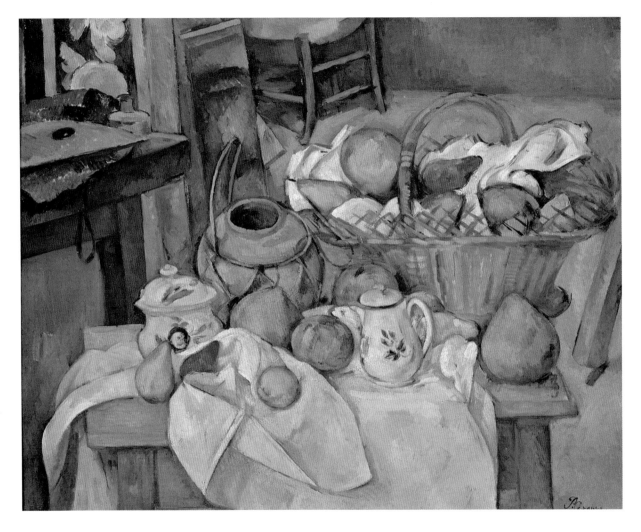

Paul Cézanne: *Still life with basket* (*c.* 1888–90)

Oil on canvas, 65 x 81cm. Musée d'Orsay, Paris, France / Bridgeman Images.

Cézanne's Dog

What Mathilde Vollmoeller said, or what Rilke
said she said at the Salon d'Automne
on a day of rain, was that Cézanne's intention
was not to describe, to say: this the figure, this the ground,
the object or the space around it, but to be accurate
to his sensations – half-red, blue-red, green –
so if he wasn't sure, if the precise tone evaded him,
he'd stop and start in another place until
the whole thing fought against itself – the bottle
with the dish, the apple waging war
against the pear – when, exhausted by his efforts,
he'd turn to his self-portrait once again
and paint himself like a dog who looks
into a mirror and thinks, there's another dog.

The House of the Hanged Man

There are no cityscapes in Cézanne,
no view along the Rue de Bac, no carriage
clatter, horse manure, men in silk top hats.

Electric light appalled him, sent him back
to provincial lanes, the quarry at Bibémus
and, for bad weather, a *compotier* of pears.

The sidelong light is strong enough to cast
an elongated shadow but there are no
tree-lined avenues or café interiors,

no billiard tables or absinthe drinkers, only
his son dressed (improbably) as Harlequin,
and the House of the Hanged Man.

The Pissarro Portrait

Cézanne is trying to work out what to do
with the still life he's still working on – yellow
and red apples – looking at it from
where he sits, forgetting he's being painted.
They'd walked together *sur le motif*, Pissarro
urging 'Precise drawing is dry and hampers
the impression of the whole', 'Choose a subject
then work on everything at once', 'Don't be timid
before nature, risk mistakes and being deceived'.
But when they stop to take a break and smoke,
it's Cézanne who'll tell the story once again
how, when he was lying on the grass to watch
Pissarro paint, a passerby exclaimed
'Your assistant's not exactly straining himself!'

After Renoir snubbed Pissarro in the street
and Degas called him names behind his back –
Jew and Dreyfusard – Cézanne signed himself
'Pupil of Pissarro', the humble and colossal.
Danchev is right of course about Pissarro's
portrait of Cézanne – its air of homespun
makes you think he's the gardener not
the 'father of us all'. The cartoon of Courbet,
for instance, above the painter's head,
holding out a palette and a beer, giving
Cézanne the nod, might be his pipe-smoking

guardian angel, mocking the pretension
and urbanity of Manet's Zola portrait:
the literary lion with heroic quill and book.

They never did repeat that miracle year
tramping around Pontoise, speaking
in pictures, comparing strokes, comparing
patches, Cézanne's *daub*, Pissarro's *dab*,
swapping paintings where sky met earth and water
in one unbroken bond – 'I wasted my life.
It was only when I met Pissarro, who
was indefatigable, that I got the taste for work.'
Then everyone was dead: Emperaire in 1898,
Marion and Valabrègue in 1900, Alexis
in 1901, Roux and Zola in 1902 and finally,
when the leaves were down in Paris
and the streets were wet and the cafés
of Montmartre were lit up for the night,
Pissarro in 1903. They'd only met the once,
by accident, in the preceding twenty years –
old friends, bearing each other in mind.

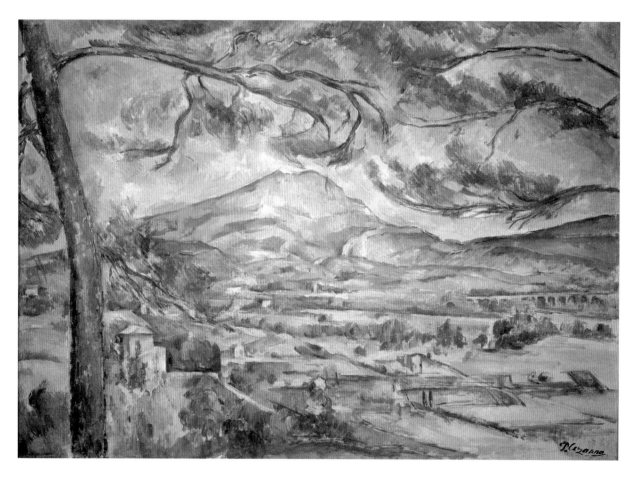

Paul Cézanne: *Montagne Sainte-Victoire* (*c.* 1887)

Oil on canvas, 66.8 x 92.3 cm. Samuel Courtauld Trust, The Courtauld Gallery, London / Bridgeman Images.

Cézanne in the Studio

In a rage with everything, exhausted
and defeated by working on the mountain,
he takes an unfinished canvas, leans it
against the wall and folds his arms.

Hortense will be bringing Paul tomorrow
but he can't think about that just now.
That pink, is it a quarter-tone too high?
He paces away, holds up a forefinger,

squints and tilts his head, but can't decide.
Leave it for now. Counting the distance
with his eyes, doing the arithmetic,
he knows everything leans; the plate's ellipse

is broken, back flipped up. He checks
each particular like Marie telling her rosary
…this, that, this, that… That pink…
No. To restrain is not always to improve.

He swears at the thought, allows himself
a smile, swears again but more gently,
then, catching the paint off guard,
sees the whole beyond its sum of parts.

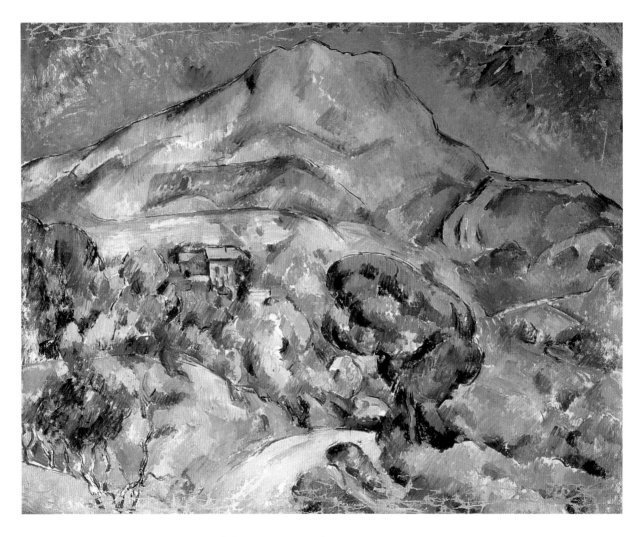

Paul Cézanne: *Mont Sainte-Victoire* (*c.* 1900)

Oil on canvas, 78 x 99 cm. State Hermitage Museum, St Petersburg, Russia / Bridgeman Images.

This Painting of a Mountain

I

This painting of a mountain and a lane,
a thirsty spruce blowing up a curve,

the mountain falling on its knees, the sky
above a yellow earth made morning-cool,

made evening-warm, a lane that winds below
a house in summer's painted wind, a wind

that stops in green and greener trees, all this –
a sensual sky and summer not yet done –

is not to say *adieu* to yellow roads
and gusty trees, this hulking up beyond,

but just the longest doting way to say
bonjour bonjour to summer's massive house.

II

To say *bonjour* to summer's massive house,
to call it red and yellow, blue for shade,

to name this blueness as the breadth of sky,
this yellow but the dustiness of lanes –

a tree that shakes itself in summer wind,
a wind that blows us mortal, out and in –

to know we pass our days in summer's house,
our home below the beaten sky of gold

that Moses saw above Mount Horeb's height,
is just my doting way to say Cézanne

has seen it better, the sacred and profane
in this painting of a mountain and a lane.

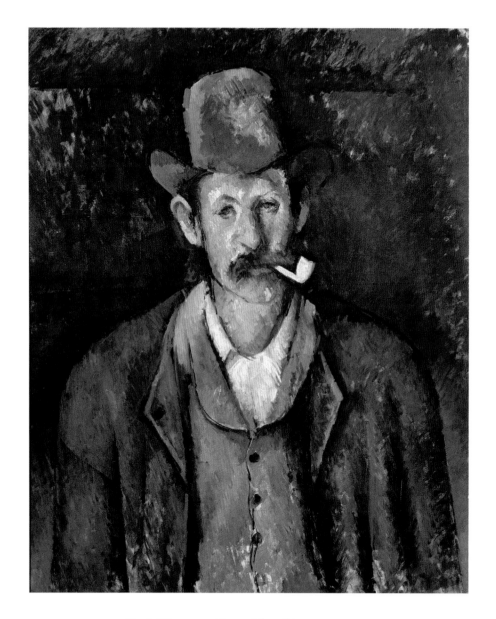

Paul Cézanne: *Man with a Pipe* (*c.* 1892–95)

Oil on canvas, 73 x 76 cm. Samuel Courtauld Trust,
The Courtauld Gallery, London / Bridgeman Images.

Man with a Pipe

As if the human heart had these two sides,
advancing and retreating, the waistcoat's like
two waistcoats sewn together at the back,
face in shadow, one ear in better light.

His workman's shoulders, contrary-wise, are set
and worlds apart so that nothing is intact,
from the tucked-in shirt collars (one's omitted)
to the hat. The colour, if you can call it

colour, is never merely brown or grey –
God breathing life-breath into Adam's
nostrils 'As new waked from soundest sleep
soft on the flow'ry herb I found me laid' –

but rank topsoil and clay: the common man,
old reprobate and lover. His only coat
has had enough of muck raking and hay,
the cuffs are thin and frayed (if we could see them),

the shirt is grimed with tobacco-sweat and tar
and the pipe, the clenched and brittle pipe, has been
dropped into a bean drill, lost in a haycock
or buried on the slopes of Sainte-Victoire.

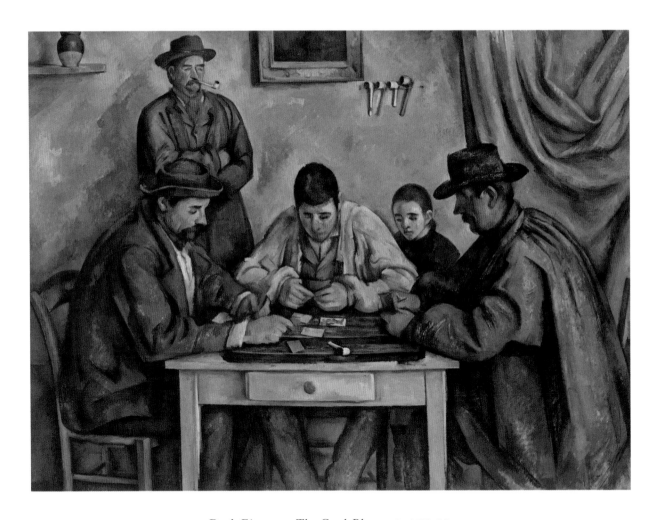

Paul Cézanne: *The Card Players* (*c.* 1890–92)

Oil on canvas, 135.3 x 181.9 cm. The Barnes Foundation,
Philadelphia, Pennsylvania, USA / Bridgeman Images.

Léontine

I daren't to move an inch, not with his eyes
looking, well sort of looking without seeing
and talking to himself like papa used to
when his breath smelled, muttering sentences
like nobody was listening or no one saw.
He said a bad word, which nearly made me laugh.
I had to stand up close to Monsieur Paulet
and be staring at his card, an ace of hearts –
I knew the card from papa's games – a red heart
with whiteness all around it, two big thumbs
with darkness under the nails. There were chalk marks
round my feet where I'd have to stand each time,
still more across the table for Monsieur Paulet
where his elbows had to go. Père Alexandre
sat the other side, wearing his usual hat.
He pulled a lucky face.

 Just when I thought
I couldn't stand it, he woke up or seemed to –
Monsieur Cézanne I mean – like he'd been sleeping
and I'd been standing like this in his dream.
He's got more money than sense, maman said,
and let that be a lesson! Then, to no one
in particular (or to the table), he signalled
'Time to take a break.' He turned to me
and asked me if I'd like a biscuit, waving
his hands as if a biscuit might appear.

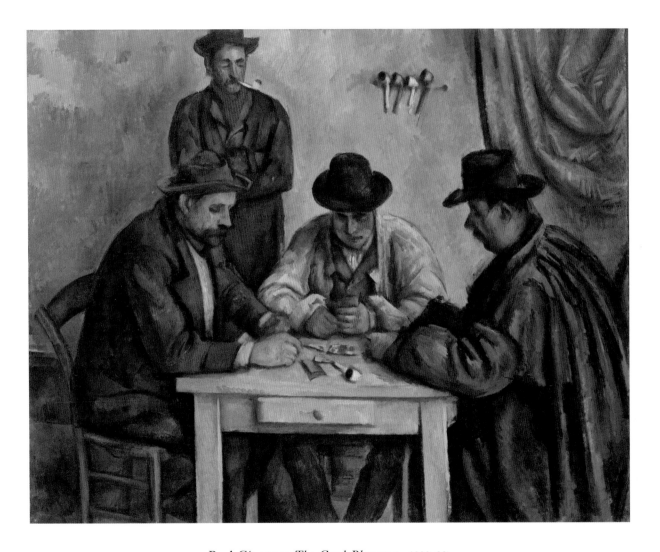

Paul Cézanne: *The Card Players* (*c.* 1890–92)

Oil on canvas, 65.4 x 81.9 cm. Metropolitan Museum of Art,
New York, USA / Bridgeman Images.

The men started moving about and scratching
and I had this notion that they were cows
moving in papa's barn, nudging and shifting
and certainly Monsieur Paulet smelled like a cow
(well, that's what papa said). Then Madame Brémond
came bustling in without knocking first.
She told me to run along and go outside.
I knew I was going red.

 When I came back in
Père Alexandre was winking, lifting his elbow
and mimicking a drink. He startled when
he saw me, then cracked a joke that wasn't funny.
Monsieur Cézanne kept glancing back and forth
at what he'd painted, like it was some bad farm dog
or leastways something to be frightened of
and kept strict watch on. He started stroking his trousers
and seemed about to speak. I felt giddy
but then he changed his mind. I put back my feet.
There was nothing for my thoughts to do,
stood standing in the heat between the men,
so I focused on the heart, but then the heart
kept bleeding, breaking up – I felt prickly
like I'd straw pushed down my neck – the heart
was heaving till it seemed about to burst.
Then there was a ring of stubbled faces
and someone somewhere shouting *Get back! Get back!*

Rough hands were washing my face; it wasn't maman.
There was blueness and the card was gone
and I was lying on the grass. I could feel
a stick or something sticking in my back.

After that we had to pack up for the day
and of course I knew that everyone blamed me.
Madame Brémond would take me home, she said.
Fancy fainting in front of all the men!
What was I thinking, making such a fuss?
Monsieur Cézanne was pacing up and down
trying not to look while Père Alexandre
was practising his sympathetic smile.
I knew I wouldn't dare to ask about
the money, holding Madame Brémond's hand,
but then the space the missing money made
made such a heavy space I almost wept
except I wouldn't give them the satisfaction.

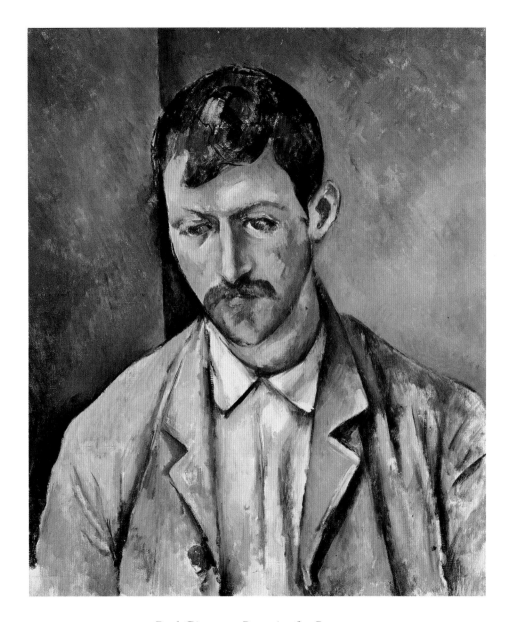

Paul Cézanne: *Portrait of a Peasant*

Oil on canvas. Private collection / Bridgeman Images.

Cézanne's Peasant

A youngish man with an aquiline nose and hooded
downcast eyes, when he walked he swayed
so much from side to side, he seemed unwilling
to progress. His hands were mostly pushed
inside his pockets, even in the middle
of a meal or walking up to receive the Host
with the priest frowning. He counted on his fingers
and he'd cup his right hand to sweep breadcrumbs
from a table into his left. When he smiled
he showed two rows of surprisingly even
white and healthy teeth.

 A farrier, middling
at his job, neither quick nor shoddy,
he rarely showed surprise and when he spoke
he spoke so mumblingly one had to relent,
at last, from asking him to repeat himself.
He'd wear the same rough shirt for weeks on end
'because it was comfortable', and when he got back
from the Front he married a woman half his age,
a farmer's daughter from Le Tholonet.
She'd wait until he fell asleep, then fold
fresh underclothes for him to wear next morning.

Cézanne paid him five francs to sit; his feet
on a newspaper, the dog left to whine
and pace outside. His boots wanted stitching
and bootblack. He only looked at the painting
once when Cézanne had given up and shouted
something then stormed off into the garden.
He stood there swaying, casting shadows about,
hands in his pockets, saying something, one word,
over and over 'Well...Well...' like a child
watching an old horse or farm machinery.
The next morning – it was a windy morning –
he brought the painter half-a-dozen duck eggs,
freshly laid, but hearing him pacing
about upstairs, left them next to the sink.

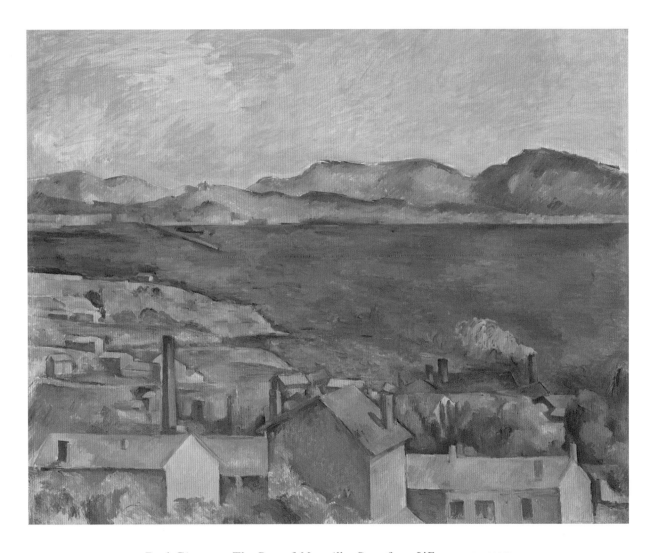

Paul Cézanne: *The Bay of Marseille, Seen from L'Estaque* (*c.* 1885)

Oil on canvas, 80.2 x 100.6 cm. The Art Institute of Chicago, IL, USA,
Mr and Mrs Martin A. Ryerson Collection / Bridgeman Images.

The Artist's Mother

After he'd gone out to L'Estaque
and walked the nine miles home –
the soil so vibrant, so harsh, reflecting
the dazzling light – he got back
to find her suddenly grown old.
She'd fallen on Rue Monclar and split
the papery skin on the back of her hand;
now she sat into the evening, lonely
with the lamp – even the small house
on Cours Mirabeau seemed too big.
So he set off at dawn for Bibémus
in order to be back in time for supper
or he'd take her out to sit in the sun at Jas
or lift her up and carry her from
the carriage to the house where he drew
her in the old armchair, sleeping.

When she stood in the cold kitchen,
she was so bent over she looked like
she was looking for a thimble
or a dropped coin. If he leant over
to ask her how she was, she'd say
'Don't make a fuss.' Only once –
when was it? July sometime
or after the hawthorn when she'd been
taking smaller and smaller steps (so long
between the butchers and the bakers) –
she asked if he would massage her feet
which didn't have an ounce of flesh
on them as they rested on his knees,
light as the willow carvings of some
forgotten saint holding up her toes
as if she couldn't bear the earth.

The Church of Saint-Jean-de-Malte

It was that that struck Rilke, pierced him
like an arrow, he said, like a flaming arrow,
Cézanne not being there at his mother's funeral

though he must have felt it and grieved it,
avoiding the handshakes and condolences,
the church gloom and walking out instead

into the light, slapping up a canvas, setting
the world to rights and so thoroughly used up
in the act of making that nothing was left over.

Renoir remembered her recipe for fennel soup
'Take a stalk of fennel and a spoon of olive oil'
while Cézanne admired the 'Flaubert tone'

he thought he'd found in his portrait of a
red-faced old woman wearing a dirty apron
who might have been his mother but wasn't.

And that's what's left, you see, *perhaps*,
of course perhaps, and *maybe* and *might have*…
Her portrait painted over in black.

Einstein's Watch

Any walk I've done, such as I have done,
which isn't much, some April morning
or summer's day, has been just far enough
to find a place to sit and think it out,
except I can't decide what thinking's for
or what the 'it' might be – love is always
somewhere in the mix or some oration
prepared to knock 'm flat. I should, I know,
have tramped the frosty fields at dawn or gone out
'botanising', naming sorrel and wild primrose,
whereas I gravitate to a seat or bench
and look myself out of looking by looking at
a lyric brook throwing up a wave
or scattering, in little wavelets, feathers,
more white feathers across the further bank.

Take this pond, for instance, its border trees,
their soon-to-be-green or rather empty branches –
empty that is apart from sidelong light
striking them sidelong all along their boughs –
at times like this (like you I'm always busy)
I imagine myself as a painter in the old mode
or rather the new made old by passing fashion.
I like to look where lapping waters meet
a grassy bank or where an oak grows up,
straight up with moss around its base and question

what it was he saw and made so much of
in shadowed earth and greenness in the water
down and down. I think – or what I'd like
to think were I not complaining in my head –
this outer world of outbuildings and birds
is but the workings of our mind, its splendour
but the splendour, if we have it, of our life.
The racket the ducks make as they land, skidding
on the muddy water, making targets,
intersecting targets, proves the world
to be exactly as it seems – gates and hedges
dripping up to Oyster Hill – and yet
this everyday pornography of fact,
this such-and-such, this now-and-then, condemns
our agency and bric-à-brac of thought
to meagre usefulness, to usefulness and want.

The ducks are lovely flyers when they fly,
their airy speed with necks full out is worth
the shock of elevation (I've got Johnson's
'sudden elevations of the mind' in mind).
But what I'd meant to say, before the quacking
started and I got myself distracted
by the real, was there's something that can't be got at,
can't be accounted for on April mornings
with lazy cloud and left-over winter chill.

Not that I'm feeling particularly elevated
myself, chewing the cud of some old business,
some indignation now the ducks have flown.

They make themselves a planet, these few ducks,
populous and watery where they live,
their view of it, communion and home,
and yet the world embraces and exceeds them
as it surely must with us – I don't mean
Milton's God looking down with mercy
or regret, but another consciousness beyond
this happenstance of sense (these seeables,
these touchables and tastes), some mystery
without a brush or two of which we go
as poor and squabbling and handsome as they.
For though the pejoratives of pond life speak
volumes for our tomfoolery and lust,
there's still this busy wildfowl congregation,
these branches struck by nearly-Easter light.

And what I say is that he saw it better,
was there better with his haversack and brush,
finding his way, making a little progress
in some great matter he couldn't abide to preach,
a Greek effort of thought enacted, achieved
or part achieved in tessellated patches,

as if the meaning – while the ducks return
and the water troubles itself with ripples,
out and further out (one of those minor
skirmishes we're prone to) – as if the meaning,
if only we'd look long and hard enough,
were in the *non finito* of the eye.

Weren't we drawing bison on a wall
before we strung our sentence-sounds with words?
And doesn't watching this cumulus reflect
(as water ruffles silvery with a breeze
that complicates what cumulus has said)
the fact that language strives towards a meaning
it is destined never to reach however much
we heap detail onto detail in our rhapsodies
of metaphor and speech – doesn't it suggest
the world is Einstein's watch in which we guess
at causes, picture cogs and inner workings
so it fits with everything we know and yet,
because we can't remove the back, will never
know for sure the world we say we're sure of?

Now the ducks have all come back, clumsily
it seems, making that contented sound
which, as they gather, rises in a crescendo
of opinions and rebukes, I've sat long enough

to tell myself there might yet be some other
explanation for late winter cohabiting
with early spring, some other-seeing beyond
the binaries, a thirdness to the world.
And what it comes back down to in the end
is that 'suddenly one has the right eyes…'
Not that I'm saying I do – no one has them
always, this side of the fire, they come
only too rarely and go, those eyes that see
the hawthorn tree, the lead-lights on the pond,
the mallards' pantomimeish colours, see them
just as they are but more exactly, heightened
by something more. And what the painter had,
apart from headaches and neuralgia, was this,
this more often, set finely down in paint.

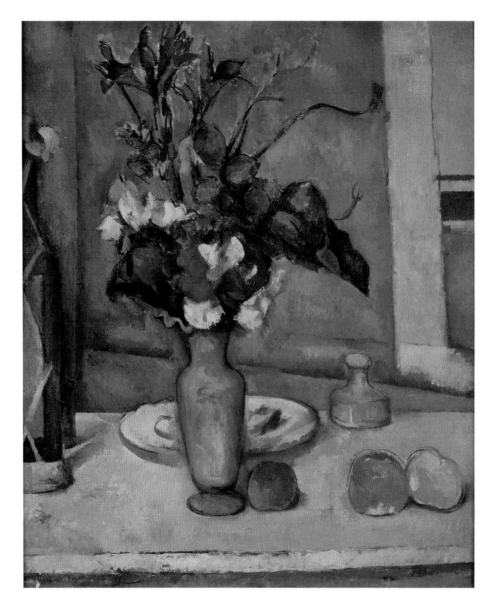

Paul Cézanne: *The Blue Vase* (1889–90)

Oil on canvas, 62 x 51 cm. Musée d'Orsay, Paris, France / Bridgeman Images.

Human Things

Lift the blind; the room
fills with winter light turning
objects on a mantelpiece
into treasures a child
holds out to show a teacher.

Cézanne took his time
with human things.
The vase leans slightly to
the left, so what we thought
fixed and stable is in flux

as we had intuitively felt.
The flowers, irises and
tulips, wither too quickly
to make something endurable
like the art of museums.

But those tablecloths –
how they bother a table
or bunch against a wall!
Ut pictura poesis: mute poetry
(and even Homer nods).

Apple, Chairback and Dish

One apple has escaped.
Ellipses run across
the fruit where they have moved
or tumbled, reminding us
of where they aren't.

The chairback, staggered
by repeated outlines –
a first thought here
and here a second – pauses
in two unfinished bows.

The dish has lost direction
or say instead that it
asserts its pattern
to the right then changes
its mind by the time it faces us.

The Disfluency of Cézanne

Take, for instance, this simple view in Spain –
unprepossessing trees, weeds that shiver
in a warm but fractious wind, a rough terrain
that leads down to a distant sail-less sea,
all this, the light adjusting or restrained,

this and every detail, hand and thumb
and page, is like, the Buddha said, an army
at the crossroads with elephants and drums.
The magician cuts off many thousand heads,
climbs a rope into the sky or summons

xylophones and gongs: all this he makes
appear or disappear at will. But if
it is a trick, some elaborate mistake –
the sense of being inside looking out
at shaley paths and unappealing wastes –

its double nature, when you look again,
is one, impartite, without periphery
or core. So wave away the cameramen
and call the painter to set the picture straight.
Let him find in imprecision a stratagem

of correction the lens cannot placate.
Make the real realer with every touch,
unfixed and drifting – have it vacillate –
cast doubt on everything we know, help us
disavow what carries too much weight.

Kūkai in Provence

'I sincerely wish you would send me some nails'
wrote Kūkai during the building of Kongōbuji,
the Diamond Peak. But when his supporters

invited him to visit, he replied 'Useless would be
my stay in the capital'. Cézanne would have approved,
frugal too and wanting, like him, to be left alone

in the midst of nature, despising wealth and fame
almost as much as Kūkai had, old monk climbing
Mount Dairyō or reciting the *Kokūzo gumonji no hō*.

'Have you not seen that billions have lived in China,
in Japan, but none have been immortal – American boys
with snapshots of their sweethearts on Omaha Beach,

Hiroshima girls with keloid scars? You too are like
the sun going down in the western mountains,
a living corpse gathering your knapsack and brushes,

a slice of bread and cheese, walking to the mountain
one last time in order to build, mark by mark
and nail by rusty nail, a monastery with courtyards

and plum blossom – renouncing this good civilisation,
the triple world, knowing only too well that discipline
in the woods alone lets us enter the eternal realm.'

Il Était Plus Grand Que Nous ne le Croyions

Consider now his anti-type, the impeccable Manet –
jacket nipped in at the waist, English jodhpurs,
slender feet and walking cane, whistling

at the scandal of *Olympia*, her maid and cat, flowers
wrapped hastily in newspaper. Compare
Cézanne's itchy green with Manet's etiolated grey

and gentlemanly black; set the music of the Tuileries
against *Les Grandes Baigneuses*: buxom girls who squat
to wash their feet or comb their Magdaleney hair.

Then imagine Manet, that polished man, with gout,
suffering fulgurating pain, unable to walk
to the studio, attended upon by Doctors Tillaux,

Siredy and Marjolin who discuss amputation
in the living room, Manet's condition so critical
the nails of the foot come away when touched.

Picture Manet (his rectitude and cut-glass dragon vase)
squinting and frowning, feeling surpassed
no doubt, making the best of it with final flowers.

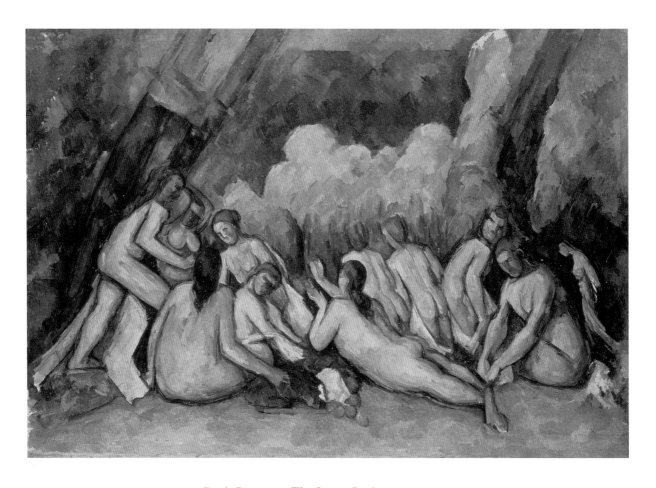

Paul Cézanne: *The Large Bathers* (*c.* 1900–05)

Oil on canvas, 130 x 193 cm. National Gallery, London / Bridgeman Images.

Afterthought

Your sugar bowl and ginger jar have been saved for the nation
along with a tablecloth and purse. Your ridiculous hat

still gathers dust in the studio. I'd been thinking
about my father talking about the war – Bink Marsh

losing an arm, Godfrey Copage doffing his red beret,
'A sadness I can scarcely endure' – rain in the coach yard,

sitting at my grandmother's table colouring in a goose,
hearing you come to the kitchen door, and letting you in.

The Red Teapot

This metal teapot, big enough for two,
red, except where rust patches show through,

and the lid's hinge broken off, the spout
a good pourer (it doesn't drip), no doubt

passed from hand to hand, warmed up in
the kitchen then carried to the lounge, aspiring

to nothing more than what it serves – form
used up in function: picture it reborn

in yet another still-life by Cézanne
whose post-box hue and cry completes the plan

of complimentary colours: the usual apples
(each one propped up by a coin), a spill

of apricots perhaps, a tangerine,
a teaspoon, water pitcher or soup tureen

all floating, almost floating on a cloth
that ushers in redemption – grief and loss

and joy together in blue and green and red,
like 'objects set on snow' as Balzac said.

Art Tutorial

i.m Elma Thubron

'Cézanne would never paint a black shadow –
a violet-blue perhaps, with ochre highlights
but never grey. He'd let the colour grow
along his brush, leaving the canvas white

between the strokes. Look at this,' she said,
opening the book at mostly tablecloth
(a gift passed on to Bonnard, chequered red)
'this sugar bowl and dish, this coffeepot…'

But most of all she talked about the space
and how it left a nothing, no, not a nothing,
a crucial gap that highlights Marthe's face
and lemon dress, the dog and crumpled napkin –

how napkin, wife and dog are somehow blessed
(I think that's what she said) by emptiness.

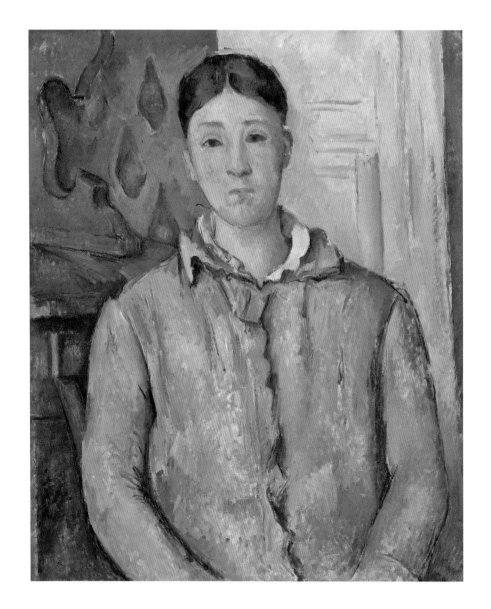

Paul Cézanne: *Madame Cézanne in Blue* (1888–90)

Oil on canvas, 74.1 x 60 cm. Museum of Fine Arts, Houston, Texas, USA /
The Robert Lee Memorial Collection, gift of Sarah C. Blaffer / Bridgeman Images

Rilke Writes to His Wife from the Salon D'Automne

Paris VI, 29 Rue Cassette, 13th October 1907

How awkward she seemed, the picture cut in half,
the light and darker side choreographed
by her cloudy blouse and strangely missing hands.
Count Kessler turned to me and said 'Cézanne
pursues the line of beauty here – a line
that flowers, literally flowers, in the design
of the buttoned bodice meeting at the throat
in a petal-like white collar revealing an almost
stamen neck, columnar, to emphasise
the tilt of her wounded head and mismatched eyes.'

He said 'He must have loved her just this much,
unsuited though they were. Look how rich
he makes her in her bourgeois cotton blue
and counterpointed face. No *bienvenue*
greets us perhaps, there's something almost mordant,
almost sad about her countenance
no doubt, but is the feeling hers or his
or all of ours? And have you noticed this?'
He reached to touch my arm. 'The wallpaper,
its clumsy pattern fills the right-hand corner.

Now what does it remind you of… tears?
Heavy falling tears? And what appears
to be the bracket of a shelf – so insistent
it breaks the picture's logic, magnificent
in its wrongness, a kind of vice that grips
her anxious-pleasing mind and holds it clipped
in stillness, voiceless in agitation – it captures
doesn't it, our hankering and fear,
our common lot.' My darling he put it better,
much better than I can writing you this letter.

And while we looked she seemed deserted, this wife
and mother imprisoned in her afterlife
of paint, not knowing herself, not known, unsure
why she's given to suffer or why we all are…
Well, the feeling passed and soon Count Kessler
went to speak to Meier-Graefe. It's raining
extravagantly outside. Please write again,
I miss your loving letters. One lives so badly
coming into the present unfinished, unsightly.
I see you smile. Only this, then… for Sunday…

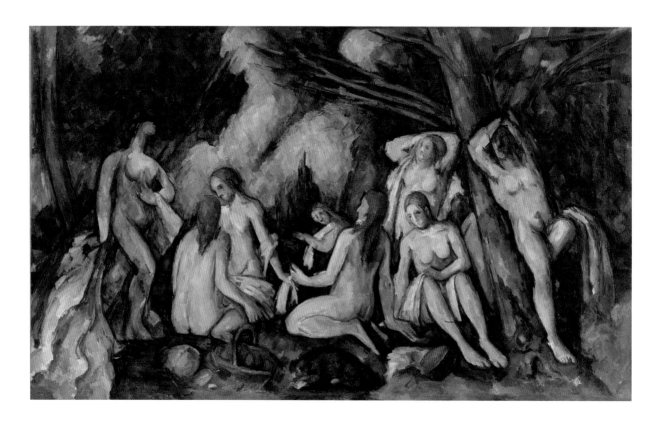

Paul Cézanne: *Large Bathers* (1895–1906)

Oil on canvas, 132.4 x 219.1 cm. The Barnes Foundation,
Philadelphia, Pennsylvania, USA / Bridgeman Images.

Morning in the Studio: *Les Grandes Baigneuses*

The sky through the studio window was so blue it darkened
 the chairs and diminished the Persian patterns
of the rugs like transposing music for soprano to the male voice.
 Inside, the pictures, his pictures – unfinished,
restarted, worried over, paced towards and backed away from –
 seemed colour-solved in the greyness of the room.
He would begin with the mountain but there was something
 wrong about the Bathers that needed fixing –
the flex of an ankle, the shifting of weight across a hip.
 They were like dinosaurs in the swaggering green,
insecurely sexed with their hands above their heads.
 He wanted earthed Etruscan statuary; he wanted
voluptuaries of the sun, but some were missing limbs
 or had their heads blown off, others had broken wrists
and severed fingers. They were like crippled monkeys
 under cathedral trees: they were the century to come.

This Perpetual Dazzlement

Leaning against the sun-sheltering wall at the pebbly cove of l'Ouille
 where Matisse and his family bathed – Pierre,
Marguerite and Jean, Amélie posing in her shift, her bathing robe,
 seated against the muscled cliffs or standing beside
the asphodels and palms, the figs and oranges; the family staying
 at the Hôtel de la Gare; loose Phrygian bonnets, money worries,
the stench of rotting fish; the room he rented to watch the fleet
 return with sardines and anchovies, nets laid out in the sun,
swimming at l'Ouille because the townsfolk, who carried their
 chamberpots nightly to the sea, used the harbour at Collioure
as a latrine – Matisse's scorching summer brings it all back home:
 the open window above the sandal maker's shop,
Jean and Pierre allowed to run amok who, after the sneering laughter –
 'A conman in a silly hat, half-charlatan, half-anarchist' –
were proud enough to call themselves the sons of Fauvists.
 Matisse looked back on those few months in horror and dismay –
how in panic he wrote to Signac begging for those few words
 from an article by Bernard, the one he'd read in St Tropez,
till a postcard arrived in Signac's flowery hand, dated
 14th August 1905, bringing final reassurance from Cézanne:
'Line and colour are not distinct' – the master's lesson –
 'When colour is at its richest, form takes on its fullest expression.'

Cut-outs

'Their bodies, clumsy in their way,

under the leaf and lemon spray,

have morally sustained me

in my venture as an artist.' [1]

1. 'Traitors to their country… lovers of physical and moral filth' (Rochefort on Zola and Cézanne). 'At the Salon D'Automne in 1905 people laughed themselves into hysterics before his [Cezanne's] paintings' (Leo Stein). 'An unframed canvas on show in an empty window. A few canvasses inside with their faces turned against the wall.' (Vollard's gallery on the Rue Laffitte). Boys bathing in the Garonne. Cut flowers in a draughty room. Drawing ballerinas during the worst of it.

When a dealer promised to take

two conventional still lifes, Matisse

pawned his wife's ring and made

his daughter scrape off everything. [2]

2. Amélie pawned her emerald ring, a wedding present, to help Matisse raise the 500-franc down payment for the *Three Bathers* – an inexplicable painting far beyond the young couple's means. 'If I yielded I knew it would be my artistic death, particularly since the hands of the butcher and the baker were outstretched waiting for money.' Marguerite remembered aching arms.

'If Cézanne is right, then I am right!'

Wheeled around the Louvre

one last time, pausing now and then,

to take in Raphael and Rubens.[3]

3. Senseless. Shameless. Infantile monstrosities. (Responses to Matisse's exhibition in Berlin, 1909.) Ugly. Coarse. Narrow. Revolting in their inhumanity (*The New York Times*). Decadent. Unhealthy. Unreal. Grotesque. Like some dreadful nightmare. 'I paint to forget everything else' – railway carriages full of wounded soldiers; the sound of distant guns thumping on the Somme heard on a still night in Paris; air-raid sirens at Vence.

This palisade of trees, young men

bathing, women turning their back

or washing from a stream – this

intellectual dream: this painting.

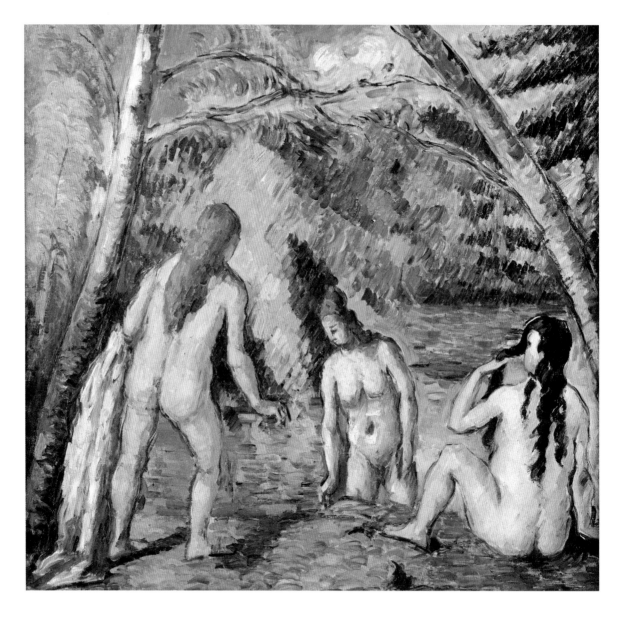

Paul Cézanne: *The Three Bathers* (*c.* 1879–82)

Oil on canvas, 52 x 55 cm. Musée de la Ville de Paris, Musée du Petit-Palais, France / Bridgeman Images.

Matisse in the Studio

There now, there: the door is closed – the time
his doctor prescribed. He already knows
when lunch will be served, when he must put up
his brushes for the day. He won't think
of another sleepless night drawing an oak leaf
or the mosquito Lydia caught, frantic in a sealed jar.

Amélie's rage, his daughter's accusations –
beaten with a steel flail; suspended by her wrists;
held under water – can't enter here,
though he feels them like Lacstrygonians,
like Cyclops at his door. The ritual calms his nerves –
colour squeezed into coils, a clean new rag.

The half-finished canvas mocks him, a colossal
problem – oranges and decanters, the pinned
expanse of *toile de Jouy* – while Marguerite mouths
evasion, decoration, apostasy. His hand shakes
but he knows where to start, saw it last night
as he sat to rest his eyes. He must begin with deletion.

But before he allows the vine to burgeon
into a great elaboration, part armature part protest,
before he begins in earnest – for now the leaf
is finished and the mosquito has been released
into the night – he turns to the *Three Bathers*, inclines
his head in a slight bow and takes up his brush.

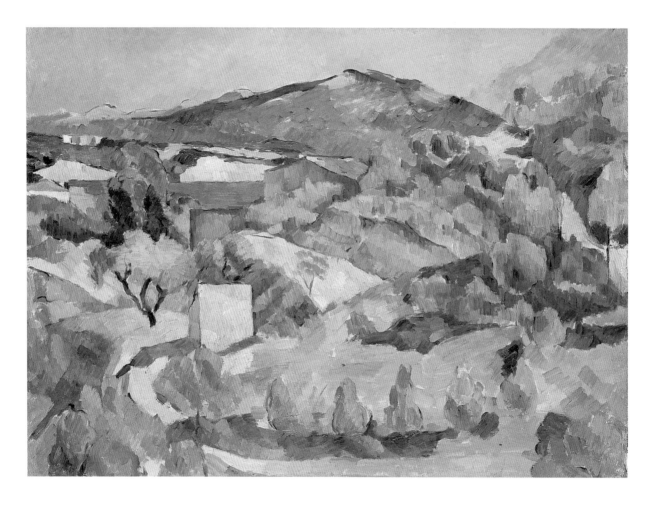

Paul Cézanne: *Mountains in Provence (L'Estaque)* (*c*. 1879)

Oil on canvas, 54.2 x 74.2 cm. National Museum Wales / Bridgeman Images.

Roger Fry at Langham Place

'A man of profound sensibility but exacting honesty'
is how Virginia Woolf describes him – ascetical,
standing in evening dress silhouetted by the slides
he asks for, lifting his pointing stick, discoursing
on Rembrandt, Chardin, Poussin, a roll call
of wonders, and somehow, she tells us, he sees them
afresh, pausing and pondering, betraying his
fastidiousness, calling for the next slide, gazing
through his spectacles, rethinking, refiguring apostles
and cherries, the funeral of Phocion, till finally,
calling for a late Cézanne, then stopping again, looking
again (the audience hushed, looking at him looking,
raising his stick but stopping, baffled), he shakes
his head and rests his stick on the floor. It went, he said,
beyond any analysis of which he was capable.
And so instead of saying 'Next slide', he bowed,
and the audience emptied into Langham Place.

For the Artist of Anahorish

Listening while I cook to archive footage
of Heaney reading his poems, the poet
is interrupted, mid-recitation, by the telephone,
the one he'll later use to contact Brian Friel.

Then whoever's recording, a voice just out
of shot, stops him, mid-Troubles,
to ask for a pause while a lorry goes past –
the coalman with his coal-bags in Magherafelt

or a heavy payload for the bus station.
It's so here-I-am-at-home I'm startled
when he begins again with 'I loved the thought

of his anger' for there's that draft-dodger
Paul Cézanne, painting unmolested at L'Estaque
despite the know-it-alls and sods and nincompoops.

The Quarry at Bibémus

The painter 'feeble in life' took the carriage
from Rue Boulegon – an artist with 'sick eyes'
as Huysmans said, a 'painter by inclination' –

then hiked his way to the abandoned quarry
to further his experiments with rock,
with quarried rock and pine. I catch the bus,

waiting in the cold with worried workers
(the bus is late). Schoolchildren press inside
then empty at the Lycée Paul Cézanne.

A boy, say four or five, with his silent
neat maman, clambers on halfway
through a conversation he's been having

with the sky in a dialect I can't hope
to understand, urgently talking, exclaiming,
rocking and kicking with the bus's to and fro.

His marvellous tale has yet to reach conclusion
when she helps him down, holds his hand,
then steps into the sunshine near the park.

I was the boy with his head in the clouds,
the boy who couldn't hold a cricket bat,
who'd put a screw in backward if he could.

Sufficient Blueness to Give the Feel of Air

In paint Cézanne has shown the means whereby
we draw the heavens down to earth and why
this shadowed rock in mid-July will foster
a cousin blue, a sister blue, and sky.

A Worm Composing on a Straw

Wallace Stevens on his deathbed is calling
for the priest. The priest bends somewhat closer,
holding a cross or he becomes a firecat

where the swerving bucks go clattering.
Stevens tries to breathe. A bluish wind
which is whispering something large – it may be

winter or summer, there are leaves or they
have fallen – is quarrelling the trees. He shuts
his eyes. The world is peppermint and cloves.

Snowflakes fall that soon are falling fast
over Hartford, Connecticut, its law courts,
offices and schools; falling now as rain

on the mountain, a laundry cart clattering
over the hill, Cézanne muttering about
sensation and a more than sensual blue,

rain in his eyes, the apples spiked and bruised
and sent off to the cider-apple heap.
The poet strives towards a better world

beyond the Father and his foes, the usual
yes and no, some provocation, while
the painter takes his place in summer's grip,

the reddest earth, a savage too-much green
and asks 'Is art really a priesthood that requires
the pure in heart to belong to it completely?'

Better this wrongheadedness, under
the linden tree, than all those bristling nos
like firecats in the snows of Oklahoma.

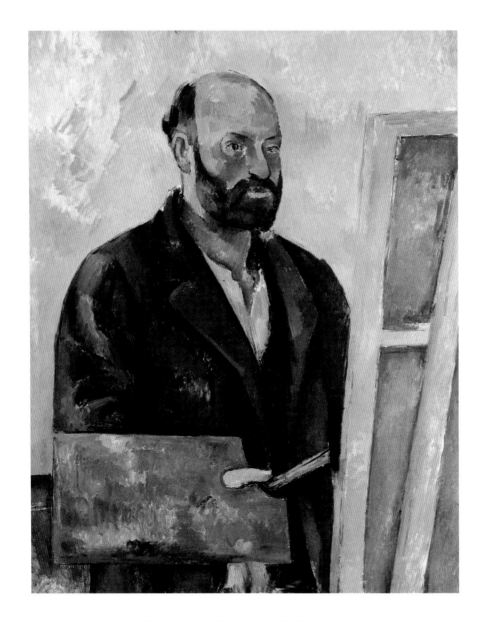

Paul Cézanne: *Self Portrait with Palette* (*c.* 1890)

Oil on canvas, 92 x 73 cm. Buhrle Collection, Zurich, Switzerland /
De Agostini Picture Library / E. Lessing / Bridgeman Images

Salt

There might be a word for canvas left bare
here in the shadowing, here at his throat –
a granular light, frost-showing weave
stippling his beard and salting his gaze.

And now his coat, his waggoner's cloak
– the statuesque Picasso would quote –
is speckled and glittered, or is it blistered
and spotted with red? O say is it hurt?

Along the edge of his workman's vest
something brightens under the dirt
that pinpricks the contour of a black lapel
where graze-like, star-like leavings show.

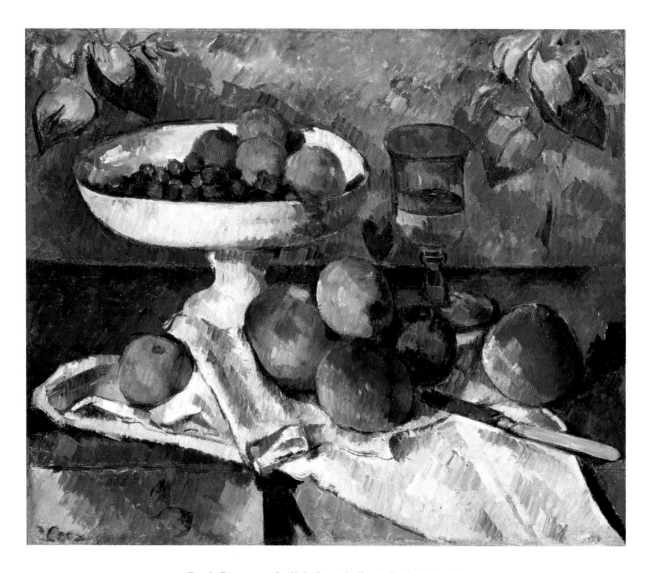

Paul Cézanne: *Still Life with Fruit Dish* (1879–80)

Oil on canvas, 46.4 x 54.6 cm. Museum of Modern Art, New York, USA / Bridgeman Images.

At the Vollard Shop

Bonnard stands to the far right in Maurice Denis' painting,
in front of Denis' wife who catches her husband's eye

at the Salon de la Société Nationale, 1901.
He wears an overcoat, carries a cane and gazes in profile

at the painting inside the painting, Cézanne's
Fruit Bowl, Glass and Apples, the hub around which

the suited men revolve – Redon cleaning his glasses,
bearded Vuillard and the rest. The colours of the painting

inside the painting stay inside the painting, for the world
is beaver-black and frockcoat, stovepipe and boot.

The Three Inseparables

'Do you remember the tree that leant
and talked confidentially as Baille, you
and I bathed or lay naked in its shadow?'

Baille became professor of optics and acoustics,
Cézanne went back again and yet again
to bathers under trees (no one wanted them)

and Zola, after talking for half a century,
living, as one biographer put it, a life
as conventional as a retired grocer, died in bed,

murdered if the deathbed confession
of a stove fitter can be believed. 'Soon, *mon cher*,
we'll go out fishing again, if the weather holds.'

Bathers at Rest

This man who doted on his son,
who studied Veronese and Poussin,
Rubens but chiefly Giorgione,
painted bathers so clumsily

people laughed and jeered outside
the Vollard shop. In part derived
from the *Concert Champêtre*, his women
bend to dry their feet, his men

stand to lift an arm. Timeless
in their green Edenic grove, they press
forward like the sky while nothing
presses in on them, their bathing

a playful attitude of calm.
No one wanted them. The psalm
to the sensual body, to water and sun
would soon be shouted down, chastened

among Picasso's burly whores
– smashed-up faces, hands like paws –
their Attic peacefulness undone
by *Les Demoiselles d'Avignon*.

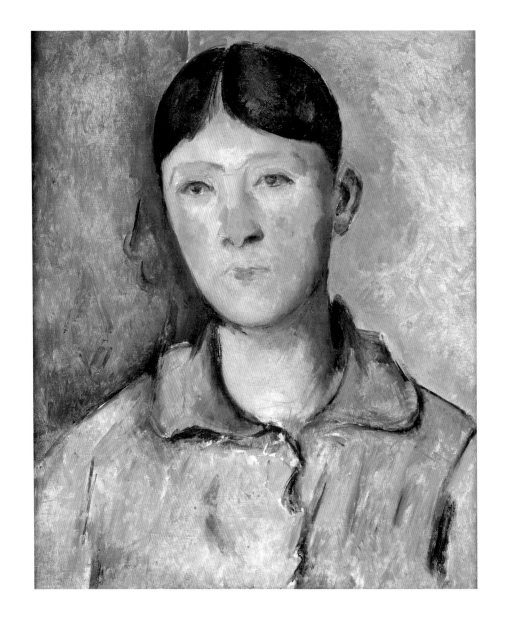

Paul Cézanne: *Portrait of Madame Cézanne* (1885–90)

Oil on canvas, 47 x 39 cm. Musée d'Orsay, Paris, France / Bridgeman Images

L'Œuvre

And was there after all the broken dishes
 and apple shadows, the olive jars and skulls –
Hortense with morning on her face,
 with evening in her eyes; L'Estaque like
playing cards, red roofs against blue sea;
 bathers bathing under trees; farmers
with their elbows on the table; the pigeon tower
 at Bellevue; a tree-lined path at Chantilly;
the road to Mont Sainte-Victoire flanked
 by pines and warmer stones (and everything
having to be held up to the light, responded to
 and lifted yet again) – was there
running through it all a sea-swell, a current
 of perpetual forgiveness, a modest degree
of freedom on which the growing good
 of the world may in part depend?

Burnt Lakes

Old, angry and mistrustful (on every side
exploitation and nitwits), the Master of Aix
sets off early, *sur nature*, a carriage ride
to the river where he says 'I could make
studies for months just by turning my head
now more to the left, now more to the right.'
Sheep come and drink under the outspread
Trois-Sautets Bridge. 'I am more clear-sighted
in front of nature. It is superfluous to say
I am always painting.' He asks his son
for marzipan, complains about the delay
in receiving ten tubes of burnt lakes no.7,
rebukes the colour merchant 'It is eight days
since I wrote, an answer please and hasten!'

Two Dozen Mongoose-Hair Brushes

I

'It poured with rain on Saturday and Sunday...
I'm not doing too badly... say hello to Monsieur
and Madame Legoupil.' After the final letter
to his son there were four days confined to bed
worrying about his father the hat-maker,
hat-salesman, exporter of felt hats (local style),
speculator in rabbit skins, money lender, banker
who bought the bank. He had Vallier prop up
a watercolour: the cognac bottle so scrutinised
it might have contained a mountain or a goose.

II

Stop at this. Wait at this. Morning in his room,
a disordered arrangement of pillows. He didn't
take his leave, no sentimentalist of clouds and
ripened pears. He didn't touch the wineglass stem
or fold the messy napkin – his son throwing
the letters away and growing bristles, his wife
wearing her final coat, the weather banking up
like ashy coals. He had been his mother's favourite,
eaten up by art. But he didn't take his leave,
leaving us with more flowers in grumous paint.

III

'Dr Guillaumont doesn't think he is in danger
but Madame Brémond can't look after him alone'
wrote the painter's pious sister to the painter's son.
The letter arrived too late. Madame Brémond
asked the neighbour to come and close his eyes.
They say Madame Cézanne hid the telegram
in a drawer not wanting to postpone a fitting
at her dressmaker's (but that probably isn't true).
'...would you be kind enough,' Cézanne continues
'to order me two dozen mongoose-hair brushes.'

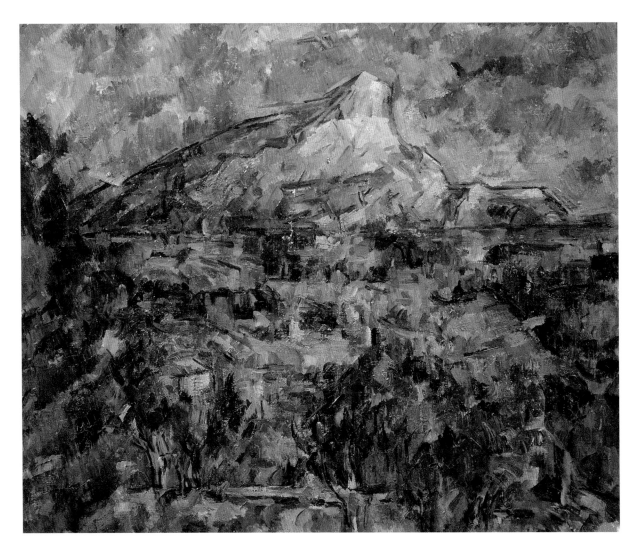

Paul Cézanne: *Mont Sainte-Victoire* (*c.* 1904–05)

Oil on canvas, 60 x 73cm. Pushkin Museum, Moscow, Russia / Bridgeman Images

The Mountain Ode

I wanted to see the mountain where the painter
saw the mountain, still far off and changing
as cloud-mass changed to out-from-nowhere sun
but the guide had mentioned forest fires
and danger, certain danger, and anyway
she said we'd see it from Boulevard du Roi René.
We'd already seen it, as it happens, briefly
from the airport bus when I'd been talking
on the phone and almost shouted There it is!
Of course I'd seen it on the Web, the place
he lugged his canvas to, the rock he hung
under the easel as ballast against another
boisterous wind, where Maurice Denis sketched him
and Roussel photographed him booted and hatted,
emerging from a wall, happy for the moment
to have these bright applauding men asking
how to see the world in coloured patches,
in cylinders and spheres (the place where later
Ginsberg stood intoning *Holy, Holy, Holy*) –
so off we went, my friend and I, and got the bus
and walked up from the studio at Les Lauves.

He met them coming out from Sunday Mass
wearing a paint-bespattered suit, courteous
and discreet, then led them up to hallowed ground –
a pig-headed old macrobite (he called himself),

splenetic, unresolved, but ardent, Renoir said,
respectful and alert, 'painting till the end'.
To their surprise he was full of conversation
'I seek to capture the confusion of sensations…
honours are for cretins, scallywags and rogues…'
He even let Roussel photograph him painting –
leaning in and stopping, waiting, then making
another mark, so I might have imagined my friend
and I walking up in that stupendous pause
between one touch and another, the valley
spreading green below us, a river-glint,
the striding viaduct with cypresses and barns.

I'd read about the Cross, the Neolithic caves,
his *locus amoenus* with tall companion trees,
that time Emperaire, slightly drunk, fell
and 'bruised himself painfully; we took him home',
the ascent of Mont Sainte-Victoire with Solari –
they'd slept in a room hung with curing hams,
Cézanne climbing a small pine on the way home
to prove himself as young and fit as ever –
but we were less ambitious and followed signs
that led past houses swagged with bougainvillea,
an empty park with swings, a mountain view
but not the view we'd come for. His mountains took him
years to get to where we've finally got them,

eleven canvases from Les Marguerites, 'measuring
each brushstroke to a geological age'
as Ginsberg said, 'looking hard enough to make
the mountain disappear', a place of desolation,
concentration and retreat, a view of heaven.

We couldn't find it. The path we followed led to
a scrubby group of pine trees near a busy road
so we scrambled up a bank and got pine needles
in our shoes taking photos on our phone,
the vista cramped by fenced and gated houses,
the mountain seeming smaller, more set back
below a not-worth-saying sky. We had to empty
our shoes and take off our socks, then walk back down
and catch the bus to Aix and to our B&B
while his chaos – stamping the visible into himself
by the act of looking, weighing up the odds,
'the cold, bright splendour of the sky... the plain's
foreboding darkness... the mountain's shaken visage' –
seemed even more the greatness of his mind,
hard enough to climb but harder still to master.

Under Linden Trees

Waving airily at my promising failures,
my art tutor – a sixty-a-day woman
who spent the mornings giving tutorials

and the afternoons looking for her handbag –
told me to go and look at Vallier
sitting on a kitchen chair under a linden tree,

the portrait in the Tate. I couldn't see
what was so good about it. I was twenty-four
and sick of reticence, each coloured impulse

held in check, those fretted-over bathers.
I wanted De Kooning charging at his ripped-up
poster girls in lipstick pink and swimsuit

acid green; I wanted construction workers
with nipples like doorbells masturbating
under linden trees, penetrating each other

on the back of motorbikes or in public lavatories;
I wanted Touko Laaksonen falling in love
with bomber pilots and jackboots, imagining

heaven as an orgy of uniforms – but I was
left with this old man, sitting in half-
profile, over-painted and eaten by shadow.

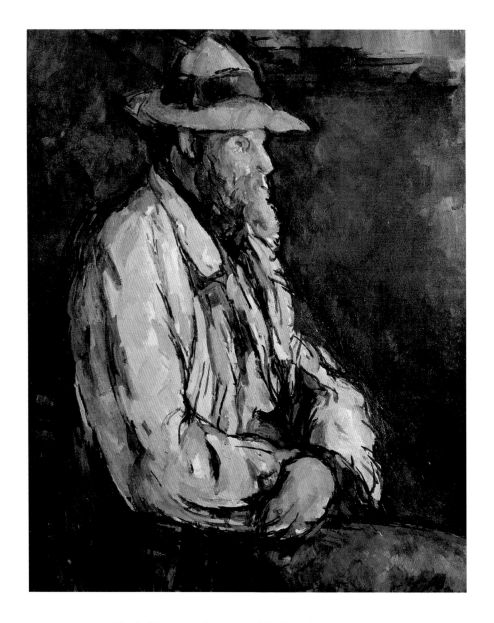

Paul Cézanne: *Portrait of Vallier, Seated* (1906)

Oil on canvas, 65 x 54 cm. Private collection / Bridgeman Images.

Vallier

It took two men to lift him
 into bed after they
found him and rattled

him in a laundry cart
 back home,
soaked to the skin, delirious,

moving between this world
 and the next
but he still got up to add

more touches
 to Vallier's face,
odd-job man and gardener

he came to rely upon
 to massage his legs
or sit for those late portraits,

in summer or in
 winter clothes,
sun on his face, as if

to be feverish and footsore
 might usher in,
might shepherd in

another Golden Age –
 old seadog
with salt still in his beard.

Opusculum

What struck me weren't
the final palettes
propped upon their box,

the skulls, the pine table
with accolades, the plaster Cupid,
a reproduction of Delacroix,

what struck me was
the north-facing studio window
framing and sectioning

and amplifying the light:
a double curtain drawing back
to leaf- and light-play,

the attempt to find, to fix,
to capture doomed
to approximation, doomed

to fail – mark abutting mark,
stroke overlapping stroke –
until Dr Gachet had to say

C'est bon Cézanne, laisse
ce tableau, Il est bien comme ça,
ne le touche plus.

On Rough Ground

You want him, still sprightly,
wearing a Kronstadt hat
and two paint-spattered

jackets, the sleeve torn
at the shoulder,
embarrassing Manet

with unwashed hands.
But he has gone ahead
with his eyes on stalks.

Rising at four to read Flaubert
or the newspapers,
Viguier bringing milk

at five, starting again
with ultramarine
and working quickly

with everything in flux –
he has become the weather,
shoulder to shoulder

with Baudelaire and Balzac.
You catch up with him
on rough ground

near Tholonet, saying
'You'll forgive me,
father, if I take your arm.'

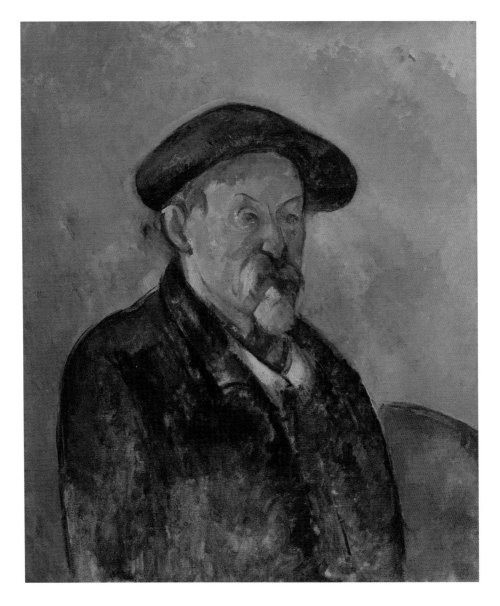

Paul Cézanne: *Self Portrait with a Beret* (*c.* 1898–99)

Oil on canvas, 64.1 x 53.3 cm. Museum of Fine Arts, Boston, Massachusetts, USA /
Charles H. Bayley Picture and Painting Fund / Bridgeman Images

Two Ways of Closing

In a story someone told me years ago
about Schubert (or was it Schumann?) unable
to sleep – the night as black as cattle settling
in a barn, snow falling on a guesthouse
dewlapped and gusseted in snow, a fire
inside with a log rousing a single flame,
a sleepless guest downstairs playing the piano
with a glass of port waiting at the high end –
the composer (whichever one it was),
maddened by the music, tosses and turns,
but when it stops at a suspended chord
leaving a silence of carriage clocks and mirrors,
he pads downstairs in his chilly nightshirt
to play the tonic and finally get some rest.

The painter 'still game' steadies himself for one
last look at himself, his beard newly clipped,
his concentration fierce enough to scare
the dogs or with an apple to conquer Paris.
He looks beyond *inquiétude* and rage
(the wall behind dressed Castiglione grey)
to where three skulls on an oriental rug,
skull-fruits issuing from a flowering vine
– fruits that ripen, fall, then flower again –
balance life and death on a shifting stage
like a cosmogram for deliberate regard.

And so he finds his answer one last time:
hands down and beretted he seems to say
we have come this far, lately, lately and hard.

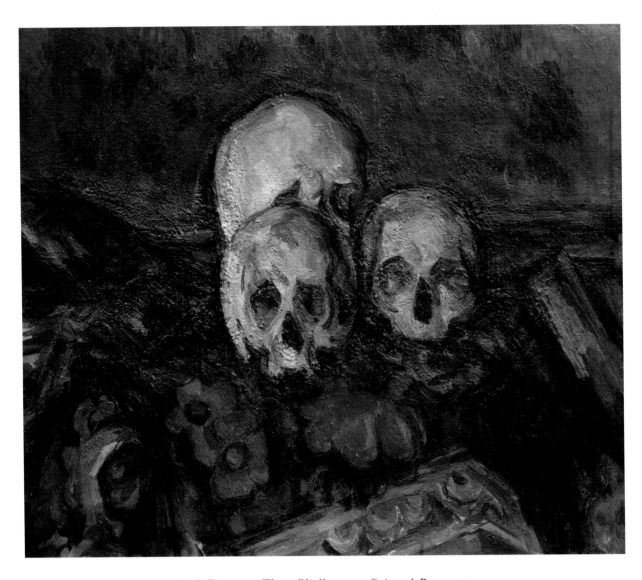

Paul Cézanne: *Three Skulls on an Oriental Rug* (1898)

Oil on canvas, 55.8 x 47.5cm, Kunstmuseum, Solothurn, Switzerland

(photo by Leemage/Corbis via Getty Images)

A Horde of Destructions

Everyone, it seems, took something from you in the end.
Braque took the tabletop your peasant leans against
and stole the browns (piano lid and beers), the sharp
orthogonals for the viaduct at L'Estaque, gable ends
and houses, the Rio Tinto Factories, breaking up
the picture into cubes and wayward facets where the sky
went missing for forty years. Picasso ransacked the bathers
Matisse had got from you, watching from his easel
while he made them twist and spread their thighs
or lift their mutilated babies where the hero statue falls.
Giacometti exploited your bald exploding head.
Johns stole your hand for the Stars and Stripes (forever).
But despite these pillagings and takings, the analytics
and disgrace, if we could linger long enough to look
at this bone-idle smoker or that woman turning round,
we'd see you've left everything exactly as you found it.

NOTES

Cézanne and the Colour Palette (16). Émile Bernard published his *Memories of Paul Cézanne* in 1907. He remembered Cézanne inspecting his palette and naming at least twenty colours Bernard had never used.

The Method of Loci (17). On 14th May 1885, Cézanne wrote asking Zola to 'receive some letters for me, and to forward them by post to the address that I'll send you later'. He was having some sort of affair: there's a draft of a love letter to the unknown woman on the back of a landscape. All we know is that he kissed her.

One Hundred Cloche Hats (21). Émile Zola moved to Aix-en-Provence when he was three years old. He entered the Collège Bourbon as a boarder – an impoverished, thin little boy with a lisp and Prussian accent, bullied by his classmates. 'And really our friendship stemmed from that,' Cézanne remembered, 'a thrashing I got from everyone in the playground... The next day, he brought me a big basket of apples.'

The Apple's Progress (21). 'According to Cézanne... a perfectly balanced whole [is achieved] by the study of the swaying balance between the illuminated and shaded parts' – R.P. Rivière and J.F. Schnerb. 'my canvas joins hands' – Cézanne cited by Joachim Gasquet. 'estimated and cherished things' – Henry James. 'Cézanne made a living thing out of a teacup' – Kandinsky, *On the Spiritual in Art*.

The Ambiguities of Place (22). 'I'm in the bosom of my family, with the foulest people on earth...' Cézanne to Pissarro, 23rd October 1866. 'When I was in Aix, I had the feeling that I'd be better off somewhere else; now that I'm here [Lake Annecy in Switzerland], I miss Aix. For me life is becoming deadly tedious... To relieve my boredom, I'm painting.' – Cézanne to Philippe Solari,

23rd July 1896. 'The people of Aix still get on his nerves, they ask to come and see his painting so that they can rubbish it; he has a good way of dealing with them: "Bugger off" he says...' – Guillemet to Zola, 2nd November 1866. 'If the looks of the people round here could kill, I'd have been dead a long time ago.' – Cézanne writing to Pissarro from L'Estaque, 2nd July 1876.

The Black Clock (25). Cézanne went to almost absurd lengths to conceal the existence of Hortense and Paul (their son) from his father out of fear of disapproval and disinheritance. Cézanne was thirty when he met Hortense; she was barely nineteen. Cézanne's father, Louis-Auguste, opened a letter from his son that mentioned 'Madame Cézanne and little Paul'. His response was to halve his son's allowance. 'Relations with my father are becoming very tense and I risk losing my entire allowance.' – Cézanne to Zola, 23rd March 1878. For months afterwards, Cézanne wrote to Zola asking him to send sixty francs to Hortense. 'the world is not to be learned and thrown aside, but reverted to and relearned' – Wittgenstein.

The Mannequins of Paris (26). 'I'm going every day to Gardanne...' – Cézanne to Zola, 25th August 1885. There are 136 drawings of Cézanne's son (often asleep). Cézanne doted on him – 'Paul is my orient'. Later in his life, Paul *fils* acted as Cézanne's agent. 'He is rather touchy, *incurious*, but a good boy.' – Cézanne to Charles Camion, 22nd February 1903. We only have Cézanne's letters to his son during the final year of the painter's life. This may be because Paul *fils* was in the habit of disposing unwanted papers at the end of each year. Cézanne died in late October which might have prompted his son to keep the letters from that year. 'Picasso kept one as a kind of talisman.' – Danchev, *The Letters of Paul Cézanne*. After his father's death, his son sold whatever he could lay his hands on – breaking up the sketchbooks

and selling the letters – thus 'subsidising a life of indulgence and improvidence' as Danchev puts it.

Madame Cézanne with Anti-representational Effects (27). Cézanne finally married Hortense on 28th April 1886, by which time their son was fourteen. Cézanne's family suspected her of gold-digging. They thought her vulgar (she was a farmer's daughter from near Besançon). Marie Cézanne (the painter's sister) disapproved of her. And yet Hortense helped her husband in business transactions, and 'When Cézanne could not sleep, she would read to him at night, and that lasted sometimes for hours' – remembered by Cézanne's grand-niece, Aline. Sitting for Cézanne was notoriously gruelling. 'One thing I didn't enjoy at all,' wrote Cézanne's son, 'was the posing... the slightest movement would drive him mad.'

Five Studies of Marie-Hortense (29). Hortense and Cézanne lived together for a while in Paris, but as time went on lengthy separations between them became the norm (though she continued to sit for him). She was always 'delicate', preferring to live in Paris for health reasons. Cézanne's friends called her *Le Boule* (the Ball or the Dumpling). She enjoyed talking and fashion. She liked to travel. After Cézanne died and she grew richer, she took to gambling. There are fifty-six drawings of her and at least twenty-four portraits. Cézanne painted her more often than anyone apart from himself. John Rewald, the father of Cézanne studies, called her 'a coarse and superficial person', thus initiating a lack of critical sympathy for her. 'Everything... has become an affair that's settled among the colours themselves.' – Rilke to his wife Clara, 16th October 1907.

Self-portrait of the Artist Wearing a Hat (31). 'I regret my advanced age, because of my *sensations colorantes*' – Cézanne to his son, 3rd August 1906.

Rilke on the Place de la Concord (32). The Austrian poet Rainer Maria Rilke wrote a series of letters to his wife Clara describing the impact of the fifty-six Cézannes on show at the Salon d'Automne in the Grand Palais, 1907. 'You have only to see the people going through the two rooms... amused, ironically irritated, annoyed, indignant...' – Rilke to Clara, 16th October 1907. 'Perhaps I'm being unfair – but all I saw was Cézanne.' – Rilke to Paula Modersohn-Becker. 'It's again the same constant raining I've already described to you so often.' – Rilke to Clara, 13th October 1907.

Sunday Bells (33). Rilke: *Sonnets to Orpheus*. In a letter to Xaver von Moos in April 1923, Rilke says the Sonnets were 'perhaps the most mysterious, most enigmatic dictation I have ever endured and achieved; the whole of the first part [twenty-six poems] was written in a single breathless obedience... without one word being in doubt or having to be changed'. Nietzsche defined the task of art as 'God-making'.

Cézanne's Dog (35). Mathilde Vollmoeller: German painter and friend of Rilke. 'I think there was a conflict, a mutual struggle between... looking and confidently receiving, and then appropriating and making personal use of what had been received; that the two... would immediately start opposing each other' – Rilke to Clara, 9th October 1907. Cézanne in the self-portraits 'reproduced himself with so much humble objectivity, with the un-questioning, matter-of-fact interest of a dog who sees himself in a mirror and thinks: there's another dog.'– Rilke to Clara, 23rd October 1907.

The House of the Hanged Man (36), painted some time in 1873 at Auvers-sur-Oise when Cézanne was working alongside Pissarro. Count Isaac Camondo bought it for 6,200 francs in 1899. 'But I'm covered,' wrote the Count, 'I have a signed letter from Claude Monet, who has given me his word of honour that this canvas is destined to become famous...' No suicide or hanging is known to have taken place in the house.

Cézanne in the Studio (39). Cézanne had two younger sisters, Marie and Rose. Marie became increasingly pious as she got older. 'Paul will be eaten up by painting,' Cézanne's father is reported to have said, 'Marie by the Jesuits'.

The Pissarro Portrait (41): see frontispiece illustration. Camille Pissaro (1830–1903): Jewish painter and anarchist. 'As for old Pissarro, he was like a father to me…' – Cézanne cited by Jules Borély, 1903. Between the 1860s and the 1880s Cézanne and Pissarro were as close as any two artists in the modern era, before Braque and Picasso, could possibly be. Rewritten quotations from Pissarro's advice on painting. Pissarro owned twenty-one Cézannes, half of them given (or left with him) by Cézanne. 'The father of us all' – Picasso. 'Between this sky and this ground and this water there is a necessary link' – Pissarro. 'All the great artists have been great workers' – Nietzsche.

This Painting of a Mountain (41). 'Not since Moses has anyone seen a mountain so greatly' – Rilke to Count Harry Kessler.

Léontine (45). The art historian Bernard Dorival believed the series of *Card Players* began with the largest painting, now in the Barnes Collection. The painting includes a young girl. As Cézanne worked, Dorival suggested, he distilled and refined the composition in smaller and smaller canvases. New evidence suggests the reverse is true. Cézanne posed his models individually in the studio rather than in groups. Madame Brémond was Cézanne's housekeeper. Léontine was the daughter of Paulin Paulet (a gardener at Jas de Bouffan). She later remembered sitting for Cézanne with her father who sits on the left in the Barnes *Card Players*. Père Alexander stands at the back, another labourer on Cézanne's estate. Léontine was paid three francs.

Cézanne's Peasant (49). 'During the day, he [Cézanne] paints at Jas de Bouffan where a worker serves as a model.'

– Paul Alexis to Zola, 1891. 'The young countryman has that somewhat dazed expression common to those who eat bacon and beetroot every day.' – Pierre Courthion, 1926. Cézanne's card players and peasant portraits have proved 'remarkably impervious to conclusive critical explanation' – Barnaby Wright, *Cézanne's Card Players*. By the 1890s Cézanne owned Jas de Bouffan ('The House of Winds'), his family's estate. He started painting his employees. Almost nothing is known about them.

The Artist's Mother (51). Élisabeth Cézanne (*née* Aubert). 'I am with my mother who is growing old, and she seems frail and alone.' – Cézanne to Monet, 6th July 1895. Danchev writes 'Their coachman, Baptistin Curnier, remembered him picking her up, delicately, carrying her from the house to the carriage, and from the carriage to her chair.' Cézanne altered his routine, setting off at the crack of dawn in order to be back in time to have supper with his mother. He'd take her out to sit in the sun at Jas, keeping her amused with a fund of little stories. There's a letter from Cézanne to his mother that suggests he treated her as something of a *confidante*. Very little is known about her.

The Church of Saint-Jean-de-Malte (52). 'That pierced me like an arrow… like a flaming arrow' – Rilke to Baladine Klossovska, 1921. 'The love is so thoroughly used up in the action of making that there is no residue.' – Rilke to Clara 13th October 1907. Gasquet said that *Old Woman with a Rosary* depicts a destitute and homeless nun. She was in fact a former servant of one of Gasquet's friends. Gasquet found the painting lying on the floor of Cézanne's studio with a pipe dripping on it. Writing about Cezanne's mother, Marie Cézanne wrote '…he loved her dearly and no doubt was less afraid of her than of our father, who was not a tyrant but was unable to understand anybody except people who worked in order to get rich.' A portrait of Cézanne's mother was discovered in 1962 under a coating of black paint.

Einstein's Watch (53). In *The Evolution of Physics*, Albert Einstein and Leopold Infeld compare the attempt to understand reality to a person trying to understand the mechanism of a closed watch: 'but he has no way of opening the case... he may never be quite sure his picture is the only way of explaining his observations'. 'I mean a reality embracing this one but exceeding it' – Marilynne Robinson, *Gilead*. 'When I remember the puzzlement and insecurity of one's first confrontation with his work ... and suddenly one has the right eyes...' – Rilke to Clara, 10th October 1907. Cézanne was diagnosed with diabetes sometime in 1890. In his letters he mentions 'neuralgic pain' and 'a much-weakened nervous system'. In his last years he often complained of 'brain trouble' (*troubles cérébraux*), especially in the heat, which he found increasingly difficult to bear.

Human Things (57). Refers both to *The Blue Vase* now in the D'Orsay, and *Tulips in a Vase* in the Norton Simon Museum, California. 'I too was an impressionist, I won't hide it. Pissarro had an enormous influence on me. But I wanted to make out of impressionism something solid and endurable like the art of museums.' – Cézanne cited by Joachim Gasquet. *Ut pictura poesis* ('as is painting, so is poetry'), 'even Homer nods' – Horace, *Ars Poetica*.

Kūkai in Provence (60). Kūkai (744–835), Japanese Buddhist monk, scholar and poet, founder of Shingon Buddhism. 'We are out of nails; the carpenters cannot finish their work. I sincerely wish that you would send me some nails as soon as possible.' – Kūkai to a supporter. The poem includes quotations from Kūkai's poem 'Letter to a Nobleman in Kyoto'.

Il Était Plus Grand Que Nous ne le Croyions (61). Édouard Manet (1832 – 1883) completed a dozen flower paintings in the months before he died. His friends bought flowers – peonies, lilacs and roses – from expensive Parisian florists. Manet's leg was amputated in the painter's living-room on April 19th, 1883. 'The limb to be amputated was in a deplorable state. Gangrene had set in, resulting in a condition so critical that the nails of the foot came off when touched' – reported in *Le Figaro*, April 20th 1883. Manet died eleven days later. He was fifty-one. According to some, Manet hadn't known his leg had been amputated. *'Il était plus grand que nous ne le croyions'* – said to have been murmured by Degas, walking behind the pallbearers at Manet's funeral: 'He was greater than we thought.'

Afterthought (63). In November 1901 Cézanne bought a plot of land half a mile north of Aix, commissioning an architect to build a house with a large studio on the first floor. In 1951 James Lord, an American writer, worked to have the studio purchased as a memorial museum, keeping the contents of the studio intact, just as the painter had left them. He raised the necessary funds but no one in France wanted to assume responsibility for its future upkeep. 'The national museums pleaded poverty and so did the local municipality.' – Callow, *Lost Earth: A Life of Cézanne*.

The Red Teapot (64). 'The cloth was draped very slightly from the table, with innate taste; then Cézanne arranged the fruit, contrasting the tones of one against the other, making the complementaries vibrate... tipping and turning, balancing the fruit as he wanted them to be, using coins of one or two sous for the purpose.' – Louis Le Bail (a young painter who got to know Cézanne through Pissarro) cited by Callow, *Lost Earth: A Life of Cézanne*.

Art Tutorial (65). Refers to *The Red-Chequered Tablecloth* by Pierre Bonnard (1867–1947). Bonnard owned Cézanne's *Bather with Outstretched Arm*. Bonnard's wife Marthe – a working-class woman Bonnard kept secret from his family, even after they were married in 1925 – grew more and more reclusive as time went on. She may have had tuberculosis, for which water therapy was a popular treatment – she is often portrayed in the bath – or she may have been an obsessive neurotic. When she died in

1942, Bonnard wrote to Matisse, 'After a month's illness, her lungs being affected along with her digestive tract, my poor Marthe died of cardiac arrest. Six days ago we buried her in Le Cannet cemetery. You can imagine my grief and solitude, filled with bitterness and worry about the life I may be leading from now on.'

Rilke Writes to His Wife from the Salon D'Automne (67). Cézanne's *Madame Cézanne in Blue* (1888–90) is now in the Museum of Fine Arts, Houston. Harry Graf Kessler: diplomat, writer and patron of the arts. Julius Meier-Graefe: writer of books on art and champion of Impressionism. 'I am still going to the Cézanne room... I again spent two hours in front of a few pictures today; I sense this is somehow useful for me.' – Rilke to Clara, 10th October 1907. 'It's still raining extravagantly out-side', 'bourgeois cotton blue', 'one lives so badly coming into the present unfinished', 'Only this... for Sunday' – from Rilke's letters to Clara.

This Perpetual Dazzlement (70). Visitors to Collioure were rare in 1905. 'It is this intense light, this perpetual dazzlement, that gives the northerner the impression of a new world...' – *Guidebook*. Matisse and his family spent three and a half months in Collioure, the family living frugally (money was always in short supply) and going for their daily swim at l'Ouille. Matisse was 'always out of doors... he scarcely took time off to eat' – Mathieu Muxart. Matisse came to see his time in Collioure as an ordeal as well as a breakthrough: 'Ah, how wretched I was down there.' 'Sometimes he feared that the blazing colours he had let loose would end by making him go blind' – Spurling, *The Unknown Matisse*. Matisse's *The Open Window, Collioure* (1905), was painted from a room above the sandal-maker's shop. He brought back fifteen canvasses, forty watercolours and a hundred drawings from his time in Collioure.

Cut-outs (71). 'One day, I had just finished one of these [still life] pictures. It was as good as the previous one, and very much like it. I knew on delivery I would get the money that I sorely needed... But I did destroy it. I count my emancipation from that day.' – Matisse. 'In moments of doubt, when I was still searching for myself, frightened sometimes by my discoveries, I thought: "If Cézanne is right, I am right."' – Matisse interviewed by Jacques Guenne, 1925. When Matisse was asked how he had survived World War II artistically, he replied that he'd spent the worst years drawing ballerinas. Surgery for abdominal cancer left him chair and bed bound; his response was to create the cut-outs.

Matisse in the Studio (73). Matisse presented Cézanne's *Three Bathers* to the Louvre in 1937, saying 'In the thirty-seven years I have owned this painting... it has supported me morally at critical moments in my venture as an artist; I have drawn from it my faith and perseverance.' Amélie ended her 41-year marriage to Matisse in 1939. She suspected her husband was having an affair with Lydia Delectorskaya, a young Russian émigrée who was to become Matisse's studio assistant. Lydia became indispensible to Matisse, running his household, typing his correspondence, and co-ordinating his business affairs. The Gestapo arrested Marguerite, Matisse's daughter, on April 13th 1944 as she stepped off the Paris train at Rennes. She had been active in the Resistance. Gestapo agents tortured her to the brink of death. She was 'shackled by her wrists and ankles to a table while two other men beat her alternately with a steel flail and a triple-thonged rawhide whip' – Spurling, *Matisse the Master*. She tried, unsuccessfully, to slit her wrists with a splinter of broken glass. Sentenced to Ravensbrück concentration camp, she managed to escape when the train was halted due to Allied bombing. Rescued by her fellow prisoners and finally reunited with her father, she began to feel his work was hopelessly out of touch.

Roger Fry at Langham Place (75). Roger Fry (1866–1934): English painter and critic. In her biography, Virginia Woolf described Fry as 'a man of profound

sensibility but of exacting honesty, who, when reason could penetrate no further, broke off; but was convinced, and convinced others, that what he saw was there'. The final two sentences are a rewritten quotation from Woolf's biography.

For the Artist of Anahorish (76). Not long after they met, Cézanne and Hortense eloped to L'Estaque where they 'sat out the Franco-Prussian War, the siege of Paris, the Commune, and the establishment of the Third Republic' – Danchev. 'The first time I went to London I came back with a Cézanne print of the Mont Sainte-Victoire. The first art book I bought for myself was about Cézanne. When I wrote 'The Artist' I was reading Rilke's letters about his infatuation with Cézanne and some of Rilke's words are included. What I love is the doggedness, the courage to face into the job...' Seamus Heaney (1939–2013) interviewed by Dennis O'Driscoll in *Stepping Stones*. The poem includes references to two of Heaney's poems, 'The Call' and 'Two Lorries'. '...the pretensions of the intellectuals of my country, a load of old sods, idiots and fools.' – Cézanne to his son, 8th September 1906.

The Quarry at Bibémus (77). The isolated quarry had been abandoned during the 1830s. The sandstone turns orange after the rain. According to legend this was due to the blood spilt by the troops commanded by Gaius Marius in 102 BC. Cézanne rented a *bastidon*, a small stone dwelling, at Bibémus. 'In short, a revelatory colourist, who contributed... to the Impressionist movement, an artist with diseased retinas...' – Huysmans: French novelist and art critic (1848–1907). 'Paul Cézanne, painter by inclination' – Cézanne to Gustave Geffroy, 4th April 1895.

Sufficient Blueness to Give the Feel of Air (78). 'Now, we men experience nature more in terms of depth than surface, whence we need to introduce into our vibrations of light, represented by reds and yellows, a sufficient

quantity of blue tones, to give the sense of atmosphere.' – Cezanne to Émile Bernard, April 15th 1904.

Under Linden Trees (93). 'The next day, as soon as it was light, he went... to work on his portrait of Vallier under the linden tree; he came back at death's door. You know what your father is like...' – Marie Cézanne to the painter's son, 20th October 1906. Touko Laaksonen (1920–91): Finnish artist famous for hyper-masculine homoerotic art, better known by the pseudonym 'Tom of Finland'. Laaksonen served as an anti-aircraft officer in World War II. 'In my drawings I have no political statements to make, no ideology. I am thinking only about the picture itself. The whole Nazi philosophy, the racism and all that, is hateful to me, but of course I drew them anyway – they had the sexiest uniforms!'

At the Vollard Shop (83). Gauguin owned six Cézannes including *Still Life with Compotier*, which is the centre-piece of Maurice Denis' (1870–1943) *Homage to Cézanne*. Ambroise Vollard, Cézanne's art dealer, acquired a virtual monopoly on Cézanne's work, becoming in the process a very rich man. He organised the first one-man show in 1895. It was at Vollard's that Matisse first saw the *Three Bathers*. In Denis' *Homage*, Vollard grips the easel at the centre of the painting while Vollard's cat, Ambroise, scowls at the base.

A Worm Composing on a Straw (79). Includes references to 'Earthy Anecdote', the first poem in Wallace Stevens' *Collected Poems*. The title is a line from 'The Man with the Blue Guitar'. 'No figure was more important to Stevens in... connection with being and seeing than Paul Cézanne' – Bonnie Costello, *A Cambridge Companion to Wallace Stevens*. 'On my death there will be found carved on my heart ...the name Aix-en-Provence.' – Wallace Stevens, *Letters*. According to the American critic Helen Vendler, Holly (Stevens' daughter) 'vigorously denied that her father was converted to Catholicism during his last illness. While at St Francis Hospital...

Stevens complained of visits by the clergy but he said he was too weak to protest.' The hospital chaplain recounted the story of Stevens' conversion twenty-one years after Stevens' death. Holly Stevens told Vendler that, at her father's request, she brought him his small jade Buddha statue (a figure he'd acquired while working on 'The Man with the Blue Guitar'). 'He turned it over and over in his hands... during his last week.' Cézanne collapsed during a thunderstorm while walking back from painting Mont Sainte-Victoire. He was discovered by the driver of a laundry cart. 'Emery raised the price of the carriage to 3 francs return, when I used to go to Château Noir for 5 francs. I've let him go.' – Cezanne to his son, 8th September 1906. 'Is Art really a priesthood that requires the pure in heart, who completely surrender themselves to it?' – Cézanne to Ambrose Vollard, 9th January 1903.

The Three Inseparables (84). Zola died of carbon monoxide poisoning on 29th September 1902. He had been asphyxiated by fumes from the coal fire of his Paris apartment. An inquest was called amid rumours of assassination or suicide. The chimney flue was dismantled but no evidence of foul play was discovered. The coroner declared death by natural causes. But in 1954 a stove-fitter and anti-Dreyfusard made a deathbed confession to the effect that he and his men had blocked up the chimney while repairing a neighbouring roof, only unblocking it the following morning. When he heard the news of Zola's death, Cézanne shut himself in his room and wept.

L'Œuvre (87). 'I've started two little motifs of the sea, for Monsieur Chocquet... It's like a playing card. Red roofs against the blue sea.' – Cézanne to Pissarro, 2nd July 1876.

Burnt Lakes (88). 'I feel exploitation everywhere.'– Cézanne to his son, 13th October 1906. 'I go to the river by carriage every day. It's nice enough there, but my weakness is getting me down.' – Cézanne to his son, 26th August 1906. 'Here on the riverbank the *motifs* multiply... so varied that I think I could occupy myself for months without moving, leaning now more to the right, now more to the left.'– Cézanne to his son, 8th August 1906. 'A week has gone by since I asked you for ten burnt lakes no. 7, and I have had no reply. What is going on? A reply, and a speedy one, I beg you.' – Cézanne's final letter, 17th October 1906.

Two Dozen Mongoose-hair Brushes (89). 'Everything goes by with frightening speed, I'm not doing too badly. I look after myself, I eat well. Would you be kind enough to order me two dozen mongoose-hair brushes, like those we ordered last year.'– Cézanne's final letter to his son, 15th October 1906. Cézanne signs off: 'I embrace you, you and maman, your old father – Paul Cézanne'. Marie Cézanne wrote to the painter's son on 20th October: 'At times he is so weak that a woman cannot lift him by herself; with your help it would be possible. The doctor said to get a male nurse; your father would not hear of it.' At 10.20am on 22nd October, Madame Brémond sent an urgent telegram to Paul and Hortense: COME IMMEDIATELY BOTH OF YOU FATHER VERY ILL. Cézanne died in the early hours of 23rd October 1906. Only Madame Brémond was present.

The Mountain Ode (91). Cézanne painted at least eleven oil paintings and nineteen watercolours from this spot, most of them dating from the last three years of his life. 'So institutes, pensions and honours are for cretins, jokers and rascals. Don't be an art critic, paint. Therein lies salvation.' – Cézanne to Émile Bernard, 25th July 1904. 'But I am old and ill and have vowed to die painting... Warm greeting from a pig-headed old macrobite who sends you cordial greetings' – Cézanne to Émile Bernard, 21st September 1906. 'I want to make black and white with colour, to recapture the confusion of sensations. *La sensation* above all...' – Cézanne cited in Denis' diary, 26th January 1906. 'We returned in high spirits, marred only by Emperaire's tumble; he was a little drunk and

bruised himself painfully. We took him home.' – Zola, *Letters*. Achille Emperaire, a dwarf with a misshapen body, lived his life in near destitution. Cézanne was very fond of him and painted a six-foot tall portrait of him. Ker-Xavier Roussel (1867–1944): French painter associated with Les Nabis. One of his photographs of Cézanne is a double exposure, so the painter seems to be emerging from a wall. 'Cézanne at his easel, painting, looking at the countryside: he was truly alone in the world, ardent, focused, alert, respectful.' – Renoir cited by Geffroy, *La Vie Artistique* 1894. According to Brice Marden, Cézanne 'looked so hard at the mountain he made it disappear'. Ginsberg discovered Cézanne as an art student, experiencing 'a strange shuddering impression looking at his canvases…' He went on to read Cézanne's letters so deeply he could paraphrase some of them from memory. Ginsberg refers to the letters in *Howl*. He made his pilgrimage to Aix in 1961.

Opusculum (96). 'Come on, Cézanne, leave this picture, it's just right, don't touch it any more.' – Dr Gachet cited by Lindsay, *Cézanne, his Life and Art* (quotation translated into French by Guilhem Monin). Dr Gachet, an amateur painter 'of no particular talent… was mad about art and artists.' 'Warm hearted and eccentric, he took in every stray animal that crossed his path. His house was full of lost cats and dogs.' – Callow, *Lost Earth: A Life of Cézanne*. 'Kindly Dr Gachet… seems to have looked after every Impressionist and Expressionist genius of his day without charging them anything. Van Gogh painted him most famously… He awaits a worthy biographer.' – Thomas Dormandy, *Old Masters: Great Artists in Old Age*.

Vallier (95). Cézanne painted six oil portraits of Vallier, including the last oil painting Cézanne ever worked on, as well as three large watercolours. 'If I succeed with this fellow [his portrait of Vallier] it means my theory will be true.' – Cézanne cited by Rivière and Schnerb. Some of the Vallier portraits are known by the alternative title *The*

Sailor. Legend has it Vallier had been to sea. 'Your father has been ill since Monday [15th October] … You must come as soon as possible… He was out in the rain for several hours on Monday; they brought him home in a laundry cart and it needed two men to carry him up to bed. The next day, as soon as it was light, he went to the garden [of his studio at Les Lauves] to work on his portrait of Vallier under the linden tree' – Marie Cézanne to Paul *fils*, 20th October 1906.

On Rough Ground (97). According to Madame Brémond, Cézanne rose at 3am. The former controller of tolls said he was often to be seen at 4am on his way to the studio where he would light the stove, make coffee and read. An apprentice to the master mason Viguier said he would bring Cézanne a bottle of milk at 5am. According to Bernard, Cézanne couldn't bear to be touched. The story goes that Bernard and Cézanne had been out walking one day, when the painter tripped. The young Bernard reached to catch him, but Cézanne flew into a rage, pushed him off and ran away. Cézanne later confided that as a child he had been almost kicked down a flight of stairs by a boy sliding down the banister behind him. Pissarro and his wife did their best to stop their children coming into sudden contact with him. Even his son, it was said, would ask permission to take his arm.

Two Ways of Closing (99). Cézanne signed himself *'Pictor semper virens'* ('painter still vigorous' or 'still game') in a draft of a letter to Marius Roux. 'I've made some progress. Why so late and so laboriously?' – Cézanne to Ambroise Vollard, 9th January 1903. 'I do believe I've made some more very slow progress in the latest studies' – Cézanne to Émile Bernard, 1905. 'What is of interest to us is Cézanne's *inquiétude*, that is Cézanne's lesson… that is to say, the drama of the man. The rest is false.' – Picasso, cited by Christian Zervos, *Conversation avec Picasso*. Cézanne's *Self-portrait with Beret*, now in Boston, is thought to be his last self-portrait.

A Horde of Destructions (101). 'A picture used to be a sum of additions. In my case a picture is a sum of destructions. I do a picture – then I destroy it.' – Picasso.

> Is this picture of Picasso's, this 'hoard
> of destructions,' a picture of ourselves

– Wallace Stevens, 'The Man with the Blue Guitar' xv.

'The discovery of [Cézanne's] work overturned everything. I had to rethink everything' – George Braque (1882–1963). 'Cézanne revolutionised the representation of the exterior world... he completely shattered the idea we had before of the whole, the unity of the head.' – Alberto Giacometti (1901–1966) interviewed by Georges Charbonnier, 16th April 1957. Jasper Johns (American painter, sculptor and printmaker) described one of the *Bathers* as having 'a synesthetic quality that gives it great sensuality – it makes looking equivalent to touching.'

'In the short century or so after his death, Cézanne has clearly emerged as the most important figure in modern art. It is no coincidence that he was venerated by all of the principal figures of the next generation – Picasso, Braque, Matisse, Giacometti – each took Cézanne as his master. This has continued ever since.... In the 1930s Arshile Gorky (who never met him) said he was 'with' Cézanne for a long time. So are they all... He is the exemplary artist-creator of the modern world. His reach is also unexampled. Not only is he the exemplars' exemplar for artists; he is also the exemplar for poets, philosophers and writers across the cultural field (Rilke, Heidegger, Beckett, Heaney...). No other painter has this reach. How to explain it remains an important cultural question... The way he saw the world (and the self) changed the way we see the world... He therefore has an importance for us that is comparable to Marx or Freud. We have only just begun to appreciate that.' – Alex Danchev, correspondence with the author, 2nd July 2016. Alex Danchev died suddenly from a heart attack on 7th August 2016.